MINOLTA

X-300s
and
X-700

NORTH AMERIC

X-370N [X-9]
and
X-700

HOVE FOTO BOOKS Herbert Kaspar

In U.S.A. and Canada
the X-300s is known as the
X-37ON or the X-9

All text, illustrations and data apply to any of the above cameras
USA Edition ISBN 0-906447-73-9

First English Edition December 1990
Published by Hove Foto Books
34 Church Road, Hove, Sussex BN3 2GJ

English Translation: Alistair Gray
Minolta Technical Advice: Bernard Petticrew
Production Editor: Georgina Fuller
Typesetting & Layout: Annida's Written Page, Sussex BN15 0NR
Printed in Germany by Kosel GmbH, Kempten

British Libarary Cataloguing in Publication Data
Kaspar, Herbert
Users guide to Minolta X-300s and X-700..
1. Cameras
I. Title
771.32

ISBN 0-906447-722-0

UK Distribution:

Newpro (UK) ltd.
Old Sawmills Road
Faringdon, Oxon
SN7 7DS

Contents

Minolta X-9

The Minolta X-9 is a variation of the X300s/X370n made for certain speciality photo dealers in the USA. It has two important features which distinguish it from its sister models.

The split-image focusing aid in the viewfinder of the X-9 is of the diagonal type. With the horizontal type of split-image aid found on the X300s/X370n you can only focus on vertical lines in the subject. If you wish to focus on horizontal lines you have to turn the camera round to the upright position. The advantage of the diagonal configuration of the X-9 is that it enables you to focus on either vertical or horizontal features.

The X-9 also has a depth of field preview button. Normally when you are viewing and focusing the lens diaphragm is held at its maximum aperture. It is only stopped down to the taking aperture at the moment of pressing the shutter release. This means you never really see on the focusing screen the true scene that will be recorded on film. This is because, unless the picture to be is taken at maximum aperture, the depth of field in the picture will always be greater than it appeared in the viewfinder because the taking aperture will be smaller. You may find that some object in the background which you thought would be nicely blurred turns out to be sharply rendered in the picture, distracting attention from your subject. The depth of field preview button enables you to stop down the lens temporarily when composing the picture to see the true depth of field. It is only really useful if the scene is relatively bright. In dim light, with a small aperture you will not see much at all.

In all other respects the instructions and advice given in this book for the X300s/X370n model apply equally well to the X-9.

First Encounter

The Minolta X-300s and X-700 may differ from each other in external appearances, but not in their well thought-out functional design, the positioning of all the operating features exactly where you need them.

If this is the first 35mm reflex camera you've ever held in your hands, you should get used to doing this properly from the start. The left hand cradles the lens from beneath

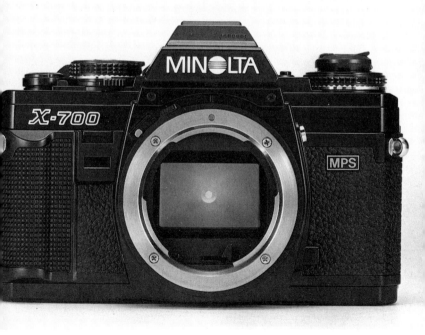

and provides you with a secure hold on the camera. The thumb and index finger can operate the focusing ring and aperture ring comfortably, as well as the focal length ring in the case of zoom lenses, where this is not combined with the focusing ring.

When holding the camera in this way, the left thumb automatically rests on a button but this has nothing to do with taking the shot. This is the lens release button - used for unlocking the lens and, when the lens is fitted, should lock into position with a click. Just below this, on the X-700, is a cable release socket and a depth of field preview button. These are not found on the X-300s.

When operating a camera, it is quite alright for the left hand to know what the right hand is doing. Your right hand encloses the somewhat larger right-hand side of the camera body, whereby the right index finger almost automatically comes to rest on the shutter release button. In the case of the X-700 this is a touch-switch shutter

The X-300s features a two-stage shutter release button. First stage: The exposure meter and displays are switched on. Second stage: The shutter is released.

release button. The special feature of this system is that you don't need to depress the shutter button in order to activate camera functions such as exposure metering; it is sufficient to place a finger on the button. The slight conductivity of the skin forms a contact between the metal point in the centre of the button and the metal ring around its edge. The minimal current which flows is, of course, perfectly safe and cannot be detected at all.

8

As the touch-switch does not react if you have extremely dry hands or are wearing gloves, it is, of course, also possible to achieve the same result by partially depressing the shutter release button (the first locking position can be clearly felt), which shows that the touch-switch is an interesting bonus rather than an essential element. The release button of the X-300s is a more conventional type, and the meter is activated by applying slight pressure.

If the shutter release button is depressed beyond the first locking position, the shutter is released.

To digress briefly on the subject of right and left, we needn't argue about where top and bottom are on your X-700 or X-300s; that much is obvious. Right and left, however, must be defined, as you can view the camera either from the front or from the back. I have therefore decided to make all references to both sides as if one were viewing the camera from behind.

When holding the camera in the way described, your middle finger will rest precisely on the AE lock/self-timer switch, which is situated on the front of the camera on the right-hand side, beneath the shutter release button. If you have an X-700, you will also find, further down next to the lens mount, a "PC" socket for connecting non-dedicated flash units.

The AE lock/self-timer switch can be operated in two ways - you can push it downwards; an arrow, followed by the letters AEL, points in this direction. This is an abbre-

The AE lock/self-timer switch on front of the camera on the right-hand side is used to lock the light reading in difficult situations, and to switch on the self-timer.

Operating features of the X-300s

1	Film speed setting ring	1 1	Eyepiece frame
2	Film rewind crank	1 2	Eyepiece
3	Back cover release knob	1 3	Mode/shutter speed window
4	Film speed window	1 4	Film advance lever
5	Film speed ring release button	1 5	Mode/shutter speed selector
6	Main switch	1 6	Shutter release button
7	Lens release button	1 7	Frame counter
8	Camera control contact	1 8	Safe load signal
9	Sync. contact	1 9	Guide socket for motor drive and winder
1 0	Accessory shoe	2 0	Coupling for winder and motor drive

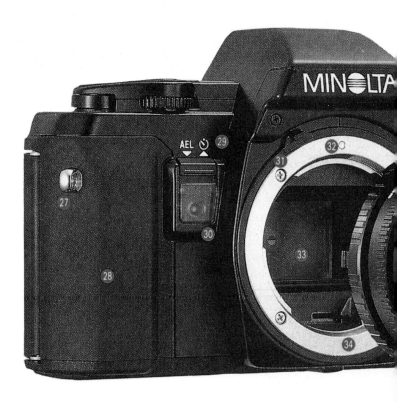

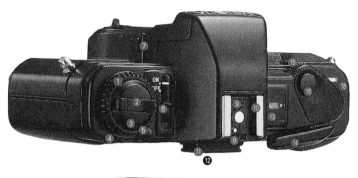

2 1 Rewind release button

2 2 Threaded mounting for tripod

2 3 Winder contact

2 4 Battery compartment cover

2 5 Motor drive contacts and locator socket for motor drive

2 6 Motor drive guide sockets

2 7 Strap eyelet

2 8 Front grip

2 9 AE lock/self-timer switch above self-timer LED

3 0 Self-timer LED

3 1 MC coupling

3 2 Lens mounting index

3 3 Mirror

3 4 Lens bayonet mount

Operating features of the X-700

1 Frame counter
2 Safe load signal
3 P/A lock release
4 Film advance lever
5 Mode/Shutter speed selector
6 Shutter release button
7 Accessory shoe
8 Flash/Camera-control contacts
9 Sync contact
1 0 Exposure-adjustment control release
1 1 Film speed window
1 2 Back cover release knob
1 3 Rewind crank
1 4 Film speed ring
1 5 Main switch
1 6 AE lock/self-timer switch
1 7 Self-timer LED
1 8 Preview button
1 9 Cable release socket
2 0 Lens release button
2 1 Winder/Motor drive guide socket
2 2 Winder/Motor drive coupler
2 3 Rewind release
2 4 Eyepiece frame
2 5 Eyepiece
2 6 ISO (DIN-ASA) table
2 7 Tripod socket
2 8 Winder contact
2 9 Battery chamber cover
3 0 Motor Drive contacts

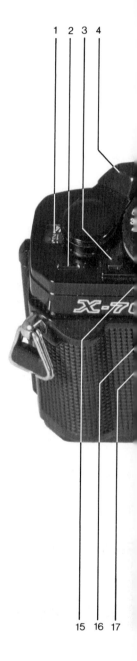

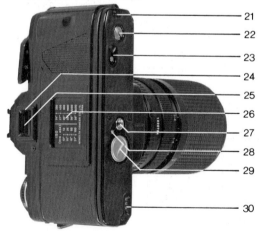

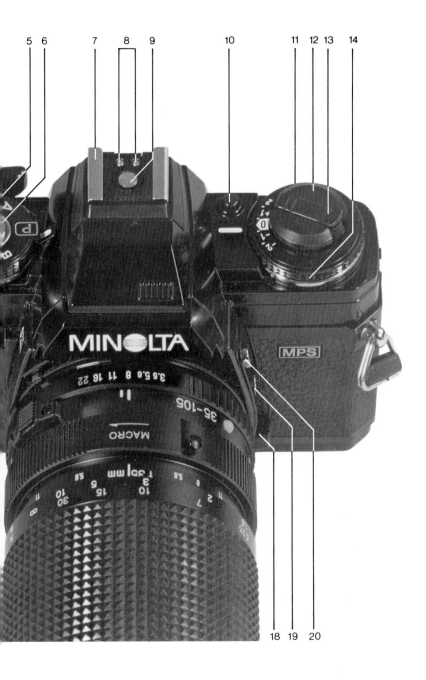

viation for "Auto Exposure Lock".

The purposes for which the AEL or auto exposure lock is necessary will be discussed later - but it is activated by pushing down this switch and holding it in position. When the switch is released, it returns to its original position.

This is not the case when you push the switch upward. This position is marked with a clock symbol on the X-300s, and with the letters "S.T." on the X-700. "S.T." stands for "self-timer" and allows you to include yourself in a group picture. In this position, it locks into place, and you must not forget to push it back to its original position after use, otherwise all the following shots will be taken with ten seconds delay.

Surrounding the release button of the X-700 is the exposure mode selector. This has two automatic settings, marked **P** for program mode, and **A** for aperture priority mode, as well as a full range of shutter speeds from 1 to $^1/_{1000}$ sec. There is also a **B** setting for making very long exposures. The dial locks at the **P** and **A** settings, and to release it you need to press the small button just to the right of the dial. In front of the selector dial is the main

LED self-timer: The electronically-controlled self-timer is started by pressing the shutter release button after raising the self-timer switch.

ON/OFF switch. This has two **ON** positions, one of which provides an audible camera-shake warning.

The mode selector of the X-300s is much simpler, since only aperture priority and manual modes are available. Instead of a large dial, this control consists of a small knurled wheel, which can be operated by the index finger.

The position for aperture priority mode is indicated by **AUTO** in the mode/shutter speed window. In this position, although the wheel is not locked, it is rather more difficult to click on to the next position, so that, in practice, it should not be possible accidentally to switch into or out of the automatic setting.

Whereas the third finger and little finger remain inactive, the thumb has an important task. It must move the film from picture to picture by means of the film advance lever. When your camera is not in use, the lever rests snugly against the camera body. In standby position, it stands out at an angle of approximately 35°, leaving room for your thumb between the camera body and the lever, so that the film can be transported after each shot by cranking the lever a further 110°. Collisions between thumb and spectacles are only likely to occur if you wear a very large

A window behind the shutter release button indicates either automatic mode ("auto"), or a shutter speed (from 1/1000 to 1 sec or B) which has been selected manually.

pair - in this case the use of a motorized film transport or contact lenses is to be recommended.

Incidentally, in the course of this book, it is not always possible to explain immediately what is involved in a particular technique or accessory - many things can only be explained at a later stage if complete chaos is to be avoided.

There are two indications that the film has been transported: Firstly, the rewind crank, which is to be found on top of the camera on the left-hand side, must turn at the same time. Secondly, an additional film transport indicator, the safe load signal, has been fitted. This is a small window on the right of the camera body, in front of the film advance lever, wherein a a red marker indicates that the film is advancing properly and smoothly. You should keep an eye on it in order to ensure that you don't shoot off a whole "film" with an empty camera. I am speaking from experience, and since then I have paid particular attention to whether a film has been loaded and whether it is being transported correctly.

While the film advance lever is used to transport the film forwards, the rewind crank on the upper left corner of the camera serves to wind the film back into the cassette. To do this, unfold the small lever on top of the crank. A small white arrow indicates the direction in which you

A red band in the upper window indicates that the film has been wound on. The frame counter is designed for 12, 20, 24 and 36 exposure films.

must turn it in order to achieve the desired result.

The rewind crank's second function is to open the back of the camera - by pulling up the lever once it is unfolded to lift the back-cover release knob - which you should only do if there is no film in the camera or if the film has already been completely rewound into the cassette. However, should you ever open the back of the camera and see the strip of film inside, don't panic. Close the back cover immediately and rewind the whole film. Only in exceptional cases, when everything goes wrong, will more than the last five or six pictures you have taken be lost, although the others could be affected by light at the top and bottom.

The rewind crank sits on top of the ridged film speed ring. On the X-300s, this is always locked in position and must be unlocked before resetting. This is done using the small button diagonally behind it to the right. The film speed ring of the X-700 must be lifted slightly before it can turn. In this case also there is a small lock button situated to the right but this is used only when setting exposure compensation.

The large button between the prism housing and the rewind crank of the X-300s is the main switch, which is used to turn the camera on or off.

Thinking of the shutter release button, you may say that this already fulfils this function. You are right, but not entirely. The camera can only be activated by means of the shutter release button if it is in standby mode, which is the case when the main switch is set to ON. No power is used as long as the shutter release button is not touched. However, it can happen that something in an over-filled camera bag presses on the shutter release button, causing an unnecessary load on the batteries. It is worth turning the main switch to OFF in situations of this sort, but never between individual shots. This would cause you to lose some of the speed with which you can react to unexpected situations, thanks to your automatic camera.

What else is there to be explained on your camera? There is the accessory shoe, in which you can see two or

three contacts depending upon which model you have. The large one serves to trigger the flash unit, the small ones transfer information between camera and flash unit.

Only two things on the bottom of the camera are of interest; the rewind release button, which you must press before you use the rewind crank, and the battery compartment cover. Although the camera designers cannot be blamed for the fact that a modern camera requires power;

The main switch can be used to cut off the power supply completely, locking the camera. The small black button on the left unlocks the film speed ring.

it is unfortunate that you are obliged to search for a coin with which to open the cover before inserting the batteries.

When viewing the camera from below, you can also see the tripod socket ($\frac{1}{4}$ inch), the coupling which allows the motorized film transport to move the film take-up spool, and electrical contacts which ensure that the motor works together with the camera in the desired way.

The interior of the camera, which we have now got to

Accessory shoe with centre contact for synchronization of Minolta PX and X flashguns.

know from the outside, is divided into three sections, one of which is the mirror box. In order to view it, you must remove the body cap or the lens, pressing in the lens release button when removing the latter.

In the centre of the mirror box lies the large hinged mirror, which makes it possible to work with lenses of long or extremely long focal length without the corners of

Inserting the batteries is quite simple - the correct position of both batteries is clearly shown in the battery holder.

the viewfinder becoming darker. We will return to this and the mirror in the next chapter. Apart from the ground glass screen, there are two levers which we have not yet dealt with. One of these sits on a moveable ring above the bayonet, the other below in the mirror box. The upper one is moved by a lug on the lens, telling the camera how fast the lens is or which aperture has been preselected, and as the shot is being taken, the other one closes the aperture of the lens to the setting which you have selected.

On the X-700, there is a third lever in a small slot next to the bayonet. This provides minimum aperture information, which enables the camera to provide correct exposure in program mode.

If you now turn the camera around and open the back, you will see, on the left, the chamber which holds the film cassette, and on the right a roller with sprockets and a take-up spool with four slots. You must feed the end of the film into one of the slots - this can be a bit fiddly, but

because of the divided spool, it is considerably easier than with older cameras. It is a good idea to insert the end of the film into one of the slots in the take-up spool first, and then place the cassette in its compartment, making sure that the sprockets engage the perforations in the film. As the film is slightly curved following its long wait in the cassette, it is pressed flat by the film guide rails above and below the film window and by the pressure plate on the

The film cassette is placed in the film compartment on the left, then the film is drawn to the right - across the film window, which is covered by the shutter blinds - and slotted into the film take-up spool. If speed is of the essence, it is a good idea to do it the other way round: Lightly crease the end of the film, insert it into one of the slots in the film take-up spool and pull it across to the left. The back of the X-300s features a film check window. One glance will tell you whether there is a film in the camera. A second, close look will even tell you what type of film has been loaded, if you note the abbreviations on the film cassette.

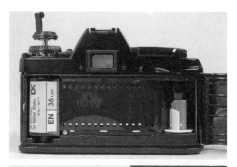

back cover. Only in this way is it possible to produce perfectly sharp pictures.

The film window corresponds in size to the 24x36mm 35mm film format and is covered by the primary shutter blind.

The interior of the camera also includes the viewfinder. The mirror box in your camera is covered at the top by the ground glass screen, which will be dealt with in the next

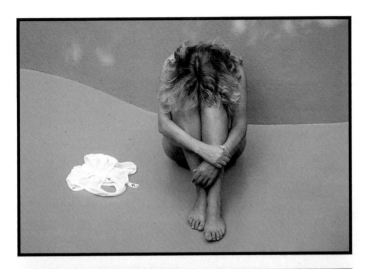

Above: *Is the girl really naked? The white shirt not only suggests that the girl has taken it off, it also introduces a visual reference point in the left-hand side of the picture, which would otherwise seem rather empty (Jurgen Kulbatzki).*

Below: *A child who is only allowed to play behind a barrier - this simple composition immediately conveys the sense of an environment which is hostile to children (Rainer Grosskopf).*

Above: *Greetings from E.T. - A slide projector can come in very handy for producing pictures like this (Michael Studtmann).*
Below: *Shop window dummies are patient models, providing the photographer with instant accessories (Josef Hilbert).*

chapter. The image which is deflected from the lens onto the screen is what you see in the viewfinder, but you do not get an unobstructed view. In order to help you focus, the ground glass screen features a split image rangefinder and a microprism ring. The subject is in sharp focus when the lines are no longer cut and displaced in opposite directions by the split image rangefinder and when the parts of the subject within the microprism ring no longer scintillate.

The light-coloured lower half of the take-up spool makes it easier to load the film in the dark. (The band inside the window in front of the frame counter shows that the film is being wound on).

In addition to these two aids, the viewfinder also provides a lot of information. Both cameras show you the exposure mode selected, and the aperture setting, as well as indicating over- or underexposure if lighting conditions are outside the range the camera can handle. They also indicate the selected shutter speed (in **P** or **A** modes) or the speed which needs to be set for correct exposure in

manual mode. In addition, the X-300s indicates the speed you have manually selected (including **B**) and the X-700 has a warning signal to remind you if you have set any exposure compensation.

To conclude this chapter, the first warning. Follow the directions on care in the operating instructions and touch neither the mirror, the ground glass screen, the shutter blinds nor the pressure plate. The resulting damage may not even be visible, but if anything is knocked out of alignment, this will lead to incorrect results, unsharp or incorrectly exposed pictures.

Single Lens Reflex - or How Does the Picture Get to the Viewfinder?

If you have ever looked at the ground glass screen of a large format camera, perhaps in a professional photographer's studio, then you will already have seen how a lens depicts the subject upside-down!

That's no big problem, once you are used to it. I know professional photographers who see everything upside down and can even manage to say immediately which way the model needs to turn. All the same, your Minolta SLR makes things considerably more simple for you. You see the world the right way round. Up is up, and left is left. How is this possible?

The reflex mirror in the mirror box was mentioned in the first chapter. This mirror is at an angle of 45° between lens and shutter, which protects the film from light as long as you are not taking a picture.

The light falls from the lens onto the mirror, and if you have not only had a look at the ground glass screen of a large format camera, but have watched billiards, then you will know how the light is deflected upwards.

The viewfinder display of the X-300.

According to the old rule "angle of incidence equals angle of reflection" the light is deflected vertically upwards, thereby immediately solving the problem of the upside-down subject. This deflection causes the image to

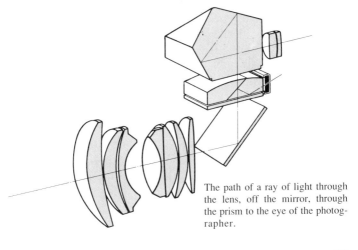

The path of a ray of light through the lens, off the mirror, through the prism to the eye of the photographer.

be projected the right way up, but still reversed, onto the ground glass screen which forms the top of the mirror box.

The ground glass screen rests against the viewfinder prism, a block of glass with five faces, which is why it is called a pentaprism, after the Greek "penta" (five). The sides of the image are reversed in this prism, and you can now, doubtless to your delight, see it right-way-up and right-way-round in the viewfinder.

This naturally has the advantage that you move the camera from left to right when following a subject which is moving from left to right. You do this without a second thought, whereas the photographer who has to get by with a simple ground glass screen, without a prism, will probably first of all pan from right to left, because this is how he sees the movement on the screen.

However, there is one more great advantage to the principle of the SLR camera, which does not necessarily depend on the prism. As the light passes through the lens onto the ground glass screen, and from there to your eye, you see exactly what the lens sees. And thus you see the image which reaches the film. Because when the picture is taken, the mirror flips up, the shutter opens, and the light no longer passes into the viewfinder, which goes dark for an instant, but onto the film, where it produces the exposure.

The actual image as captured on film can be seen with all reflex cameras at longer ranges, but only with single lens reflex cameras at close and extremely close range. In the case of the twin lens reflexes (the best known probably being the Rollei) the subject is viewed through the upper viewfinder lens, and the actual picture-taking lens is fitted beneath and, at close range, shows the subject somewhat differently from how it is seen through the upper lens. This phenomenon of parallax occurs in the same way with viewfinder cameras - so be glad that you have got your single lens reflex camera. To tell the truth you can also see the exact image which is projected onto the film on the

ground glass screen of large format studio cameras - but this type of camera is reserved for other types of subject.

Minolta is not only concerned with great leaps forward (e.g. the development of new camera systems such as the 7000), they are also concerned, as they always have been, with small details. The hinged mirror, for example, is very large. This prevents the corners of the viewfinder image being darkened when lenses with long focal lengths are used. That would, of course, have no influence on the picture, as the mirror only passes the image on to the viewfinder, but none the less, this mirror vignetting does not occur with Minoltas.

The mirror is also "anti-reflective" though this may sound paradoxical. To be more precise, it is coated, which reduces stray light and causes more light to pass to the viewfinder instead of scattering. This makes the viewfinder image brighter. The "Acute-Matte" ground glass screen

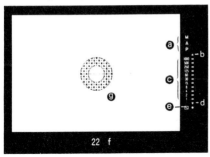

Viewfinder display of X-700
a. Mode indicators
b. Over-range LED
c. Shutter-speed scale/LEDs
d. Under-range LED
e. Exposure-adjustment LED
f. Aperture setting
g. Focusing screen

also helps in this respect. This is a Minolta speciality which, in comparison with normal ground glass screens, such as that of the SRT for instance, passes on up to 50% more light.

So everything that you photograph can be seen, brightly and clearly, in the viewfinder of your Minolta SLR.

The owner of an X-700 has the option of having the standard focusing screen replaced by their local Minolta Authorised Service Centre. A range of eight optional screens is available.

The Lens - the Eye of your Camera

Until a few years ago there was no other choice: anyone buying a camera also got the standard lens, or "fifty", as a matter of course.

"Fifty" is derived from the focal length of 50mm, which is regarded as normal for the 35mm format, as it corresponds roughly to the diagonals of the 24x36mm picture format. A focal length of 80mm is normal for medium format cameras, and a focal length of around 18mm for smaller format pocket cameras.

The 50mm is also "normal" in one other respect; it reproduces the subject more or less how it is seen with the naked eye. This doesn't mean that your subject appears just the same in the picture as it did in reality, simply because you have used a standard lens. You see the world with two eyes, and can thus perceive it three-dimensionally. The one-eyed camera cannot do this, the picture is two-dimensional. Even if you close one eye, you see things slightly differently from how they appear to the camera. The eye has an angle of view which is similar to that of a 50mm lens, if we count the area of the surroundings which is seen in focus. You can, in fact, see a lot more; unfocused and blurred, perhaps, but you still see it. With lenses, lack of sharpness around the edges of the picture is regarded as a serious fault. So the 50mm lens only sees the part which you also see in sharp focus when you concentrate on something.

And then there is a third reason why you see more than the standard lens, which is supposed to correspond to your eye. You seldom concentrate your gaze on one thing. Usually, you allow the eyes to wander; you scan the surroundings, and the many individual bits of information create a total picture.

So the 50mm lens produces an image on the film which corresponds approximately to what you see if you close one eye and concentrate on something. In addition, it has

an eye-true perspective. We will pass over that for the moment, until we deal more closely with perspective.

Nowadays, there is an alternative to buying a camera fitted with the standard lens. In many places, cameras are offered for sale fitted with a zoom lens, a lens which covers several focal lengths. I can't say with certainty which zoom is mounted on the camera in your local dealer's window - that varies from dealer to dealer. These are often zoom lenses which are not manufactured by Minolta. There is nothing to be said against these lenses in principle, and many of them can bear comparison with Minolta lenses. But there are some which should be avoided. Don't be afraid to ask your dealer for advice. He knows the brands with a high reputation, and you can save yourself a lot of trouble for the price of a phone call.

Zoom lenses are lenses with variable focal length. One type features an additional adjustment ring, these are called two-touch or rotary zooms. The latter expression comes from the fact that you have to turn the above-mentioned ring in order to set the desired focal length. The second type of zoom only has one adjustment ring which is not only used to adjust the focal length by sliding it backwards or forwards, but also controls the focusing

Minolta MD-Zoom 35-135mm,f/3.5-4.5*

when it is turned in the usual way. These zooms are called one-touch zooms. Two-ring zooms have the advantage that the focal length remains the same, once set. With the one-touch zoom, the focal length can change whilst one is focusing, or the adjustment ring can simply move of its own accord due to the effect of gravity. On the other hand, the one-touch zoom is very fast, because the focus and focal length can be adjusted with one hand movement, though this does require some practice.

If one has the choice between standard lens and zoom, then the innumerable focal lengths which the zoom offers, and which are smoothly adjustable, are obviously of interest. The greatest advantage of zoom lenses, however, is that one can frame the desired area of the subject very precisely. Correct framing is of decisive importance to the effect of the shot.

When using a zoom instead of a standard lens, it should cover focal lengths from moderate wide-angle to moderate tele. Later on, you can extend the wide-angle or long focus range by using additional zooms or fixed focal length lenses; the Minolta range of lenses includes everything

Minolta MD-Zoom 28-85mm,f/3.5-4.5

you could imagine, or - if this is your first SLR camera - even things you can't! But before I introduce the many Minolta lenses, divided into groups according to focal length and with all their individual advantages clearly explained, I would like to touch briefly on one other point which is of importance and often used as an argument for or against a particular lens - the speed of the lens.

Speed is an expression which has popularly come to mean largest relative aperture.

What does that mean? The aperture is built into the lens, a hole whose diameter can be increased or decreased. The size of the hole determines how much light reaches the film during the time the shutter is open.

Naturally, the variable aperture eventually reaches a limit beyond which it cannot be enlarged any further. If one compares this diameter with the focal length, the resulting ratio represents the speed of the lens. If we assume that the focal length is 50mm and the diameter of the hole 25mm, then the largest relative aperture or speed is f/2 or 1:2.

More precisely, it is not the actual diameter which is combined with the focal length, but the diameter of the entrance pupil, which is the projection of the aperture hole you see when you look through your lens from the front. The difference is not so important with standard lenses; the entrance pupil becomes of interest if the focal lengths are very long or very short, or if they are variable.

The calculation is not always so neat as in my example. The speed is very often f/1.7 or f/2.8 or a similarly awkward number.

The speed of a lens is always a point in favour of a particular lens if it is quite high. However, a high speed is by no means a sign of quality on its own, any more than the number of elements in a lens.

High speed naturally has advantages. One can still take hand-held shots using available light when photographers using slower lenses would have had to turn to a tripod or flash. The viewfinder image is brighter. It makes focusing

easier. The very shallow depth of field, yet another subject which we will encounter later, makes it possible to focus on the subject while leaving the background unsharp.

However, high speed also has its disadvantages. When the aperture is wide open, the depth of field can be too shallow to allow one to photograph a subject properly. Fast lenses are larger and heavier than the slower ones. And above all, the very fast ones are much more expensive than the lenses of average speed. At the same time, the difference between very high speed and normal speed often only amounts to one or two stops - frequently even less, and is thus hardly noticeable.

Those who can afford it are free to load themselves down with super-fast lenses. But those who have to struggle on a budget should consider carefully whether they want to take pictures in the gloom so often that the additional expense will be worthwhile, bearing in mind that one can always use high-speed film. Although we will deal with the relationship between film speed and aperture setting later, let us simply say, the fact that high-speed films are available is often used as an argument in favour of slower lenses. Of course, if the largest relative aperture is no longer adequate, one can turn to high-speed film. That is a big advantage. But high-speed films are also available to owners of very fast lenses to work in even dimmer light without flash or tripod.

To cut a long story short - as long as you don't want to become an available light specialist, the slower version of a lens will certainly meet your needs. The viewfinder of your X-700 or X-300s is so good that you don't require the help of a fast lens in order to achieve a bright viewfinder image. And for the few shots with low light levels where you are concerned with maintaining an atmosphere, simply use a tripod. If you don't have one handy, you can support the camera on a table, chair arm or railing and hold it steady. The reason why it is hardly possible to produce technically perfect hand-held shots under low

light conditions is given on another page in another chapter. And you can keep using faster films until even these no longer allow hand-held shots. If you still don't want to stop taking photographs, then use a flashgun, which would then be necessary even with a faster lens. Even a fast lens cannot penetrate real darkness.

Another argument often used for or against a particular lens is the maximum reproduction ratio. It states the number of times by which a subject is reduced or enlarged when reproduced on the film. 1:1 means that the subject is reproduced life-size; if it is to fill the 35mm format completely, it should not measure more than 24x36mm. 1:10 means that the subject is reduced by a factor of ten, and, accordingly, 10:1 means that it appears in the picture ten times larger than it actually is.

The maximum reproduction ratio of a lens is determined by the focal length and by the closest possible range at which a sharp picture can still be taken. That means that, when using a wide-angle lens, which reproduces the subject in the picture on a smaller scale than a telephoto, one must move closer to the subject in order to achieve the same maximum reproduction ratio as with a telephoto.

For most Minolta lenses, the maximum reproduction ratio lies between 1:10 and 1:4, which allows interesting close-up shots. However, these lenses are designed to produce perfectly sharp pictures at longer ranges, and, particularly with zoom lenses, small faults can occur at close ranges. Under normal circumstances, these faults would only be noticeable by critical examination. In other words, the faults affecting average close-up shots should not bother you.

Controlling Exposure with X-700 and X-300s

Now that you have got to know your Minolta as an SLR camera, how do you use it to obtain a correct exposure? To tell you that I shall have to digress a little.

In order to be correctly exposed, every film needs a specific amount of light. A film of ISO 100/21°, for instance, needs an amount of light corresponding to 0.1 lux-seconds. But don't worry about that for the time being, you want to take pictures with your X-300s, not sit an exam as a photographic theoretician.

The values which are important for the exposure are the film speed - it tells you how much light the film needs - and the brightness of the subject, which expresses the amount of light actually present.

A value can be assigned to each of these, x for a film speed of ISO 100/21°, y for the brightness. If you add these figures, you might arrive, for example, at 13, and the term for this is the exposure value, which can also be found in many brochures and operating instructions. An exposure value of 13, if we stick to this popular term, stands for a whole series of combinations of different shutter speeds and apertures which all allow the same amount of light to reach the film.

We shall leave the relationship between shutter speeds and apertures until a later chapter. There is one thing you might not understand at the moment. It is easy enough to find out the speed of the film - it is printed on the carton and on the film cassette. But how is one supposed to know how bright the subject is and which exposure value results from the combination of film speed and subject brightness?

That is, in principle, quite simple. And since we don't want to go into the theory any more deeply than is absolutely necessary, let us examine this simple principle and leave aside the complicated details for the time being.

A light meter, which you can buy separately and which you should have for certain quite special purposes, will tell you how bright the subject is; in most cases, however, you can simply use the one already built into your X-300s or X-700.

This light meter is built around a silicon photo cell which turns light into current. It responds quickly even to low levels of light and still manages to measure this precisely, though the current produced from the light is so weak that it must be amplified. This requires additional power, which in turn requires the use of batteries, which hardly any modern camera can do without.

The rest is simple. The more current that is measured, the brighter the subject; the light meter knows the value for the brightness level measured; it also knows the value for the film speed which has been set - it doesn't care whether this has been set correctly or not, it considers that to be your responsibility - it merely calculates the exposure value from the brightness and film speed values. This, in turn, stands for a whole series of combinations of aperture setting and shutter speed, and we shall examine this relationship in the next chapter.

The Shutter - the Stop-watch for Light

In the early days of photography, the shutter consisted, purely and simply, of the lens cap.

Carefully, in order not to shake the camera, the photographer would remove the cap from the lens, after he had drawn out the sheath from the dark slide holding the light-sensitive plate. Then he counted the seconds and when he felt that enough light had fallen on the film, he replaced the cap on the front of the lens.

What had he actually done? He had allowed the light to

strike the film for a particular length of time, he had controlled a specific "shutter speed".

You can do exactly the same with your Minolta camera, but modern film stock is happy with shutter speeds of small fractions of a second. And could you get these fast shutter speeds exactly right using the "cap off - cap on" method? I doubt it. Don't worry - you can use this method, but you don't have to.

In order to determine how much light falls on the film, your Minolta camera is equipped with a focal-plane shutter. This functions, in principle, as follows. When the shutter is cocked, the first shutter blind covers the film while the second blind remains rolled up and ready for action. When you press the shutter release button, the first blind shoots across with virtually no delay and is rolled up, exposing the film, and the light can start to take effect on the emulsion. After a certain time (we shall see later on who determines this, and how) the second blind shoots across, covering the film once more.

Now although the shutter blinds are extraordinarily fast, they still require time to perform their movements. And it takes one sixtieth of a second before the first shutter blind has exposed the entire film. So if the second shutter blind doesn't start until after $^1/_{60}$ sec or later, the first blind will already be rolled up.

But what happens if the second blind starts earlier, after $^1/_{250}$ sec, for example? Then the first blind is still rushing towards its goal as the second blind races across behind it, and a slit between the two blinds flashes across the film allowing light to pass through. The time which elapses between the start of the first shutter action and the second is known as the exposure time or shutter speed. I have not mentioned $^1/_{60}$ and $^1/_{250}$ by chance. The shutter speeds are standardized. They follow the rule that a halved shutter speed allows twice as much light to reach the film as the previous speed. To put this into practice, one whole second is taken as a reference point. This is

doubled or halved in order to produce the other shutter speeds. The result is a sequence of shutter speeds which reads as follows:

$$4, \ 2, \ 1, \ ^{1}/_{2}, \ ^{1}/_{4}, \ ^{1}/_{8}, \ ^{1}/_{15}, \ ^{1}/_{30},$$
$$^{1}/_{60}, \ ^{1}/_{125}, \ ^{1}/_{250}, \ ^{1}/_{500}, \ ^{1}/_{1000}$$

These shutter speeds are the fixed points, the whole steps in the sequence of shutter speeds - we will return to the intermediate values in another chapter.

So how does the shutter know when $^{1}/_{500}$ sec has expired? In your Minolta, as in many modern cameras, the time is measured by means of an oscillating quartz crystal. When excited by an electric current from the camera battery, the crystal oscillates 32,768 times in a second, or, in $^{1}/_{500}$ sec, 32,768 divided by 500 = 65 times. After 65 oscillations of the crystal, the second shutter blind starts to close, and the film is therefore exposed with a shutter speed of $^{1}/_{500}$ sec.

The fact that the film is exposed in strips does not generally have any effect on the picture, as long as the shutter operates evenly. This only becomes important in two cases. If a subject is moving very quickly in the same direction as the slit as it flashes across the film, the object becomes stretched out, and if it is moving rapidly in the opposite direction, the subject is compressed. The second circumstance in which the shutter slit plays a role involves the use of flash, which we will deal with later. The subject of the focal-plane shutter and its characteristics will come up again then.

The Aperture - the Light Hole

We have already come across the aperture. You will remember the question as to whether or not it is worth buying a faster lens, and the role which the largest aperture of a lens plays. You will also doubtless remember that the aperture opening is variable, and this time we are concerned with the apertures which are smaller than the largest relative aperture.

Whereas the speed is determined by the relationship between the focal length and the aperture diameter, the aperture settings are standardized. The starting point is the aperture ratio of 1:1, which is currently only provided by two extremely expensive 50mm lenses. 1:1 (f/1) means that the entrance pupil has a diameter equal to the focal length. Starting with this aperture ratio, each aperture one stop smaller should let through half as much light as the next widest one. The logical sequence of aperture stops would therefore be: 1, $\frac{1}{2}$, $\frac{1}{4}$, $\frac{1}{8}$ etc. In fact, the sequence is as follows:

f/1 - f/1.4 - f/2 - f/2.8 - f/4 - f/5.6 - f/8 -
f/11 - f/16 - f/22 - f/32

These figures state the ratio between the diameter of the entrance pupil and the focal length. But that still doesn't explain why f/1.4 should be twice as large as f/2.

It will be noticed that many of the fractions of a second have been rounded off to give convenient values. The very small errors this introduces are quite insignificant and can be ignored.

These apparently peculiar values arise because although the diameter of the entrance pupil serves as a basis for the f/numbers, the amount of light passing through the lens depends on the *area* of the entrance pupil. The area of a circle is proportional to the square of its diameter and hence, to obtain a series of f/numbers so that moving

from one number to the next higher one halves the amount of light entering the camera, the diameters of the aperture have to vary by a factor of the square root of 2, roughly 1.4, and not by a factor of 2. Thus the series of f/ numbers now a universal standard is geometric with a common ratio of the square toot of 2.

The aperture mechanism in the lens consists of several metal leaves (the number varies from one type of lens to another). Even if the metal leaves of the Minolta lens have been closed down to the smallest stop while the lens is removed, the aperture opens to its fullest extent when the lens is refitted - and remains so until a picture is taken. The exposure metering is also carried out at full aperture, known as "open-aperture metering". This has the advantage that you always see the subject at its brightest in the viewfinder.

Shortly before the shot is taken, the aperture is closed down to the stop which you have set on the aperture ring - a lever in the bayonet mount of the camera and its counterpart in the bayonet of the lens are responsible for this.

Once the shot has been taken, the aperture leaves spring back into their initial positions (largest relative aperture).

This function, known as an automatic iris, is not offered by older cameras. Some lenses - mirror lenses - get by without any aperture at all. If it is necessary to reduce the amount of light entering, this cannot be done by reducing the surface area of the light hole, and neutral density filters must be used if the shutter speed cannot, or should not be increased.

Shutter Speed and Aperture - An Ideal Pair

The focal-plane shutter in your Minolta SLR and the aperture in each lens complement one another perfectly and are dependent on one another for correct exposure. The aperture determines the intensity of light that strikes the film, whilst the shutter determines the length of time that the light is allowed to act on the film - a whole second (1 sec) or only a five-hundredth ($1/500$ sec).

And now the exposure value, which I have already mentioned, crops up again. The exposure value says how the brightness of the subject and the speed of the film must be taken into account to produce a correctly-exposed picture, though it leaves open the choice of a whole series of aperture/shutter speed combinations.

We spoke earlier of an exposure value of 13, a film speed of ISO 100/21° and the brightness of, shall we say, a very fine summer day in early afternoon. The exposure value of 13 corresponds to the following combinations of shutter speed and aperture:

$1/1000$ sec - f/2.8

$1/500$ sec - f/4

$1/250$ sec - f/5.6

$1/125$ sec - f/8

$1/60$ sec - f/11

$1/30$ sec - f/16

$1/15$ sec - f/22

$1/8$ sec - f/32

Manual Exposure

In order to achieve a correct exposure with the exposure value 13, you can set the aperture ring on the lens to f/8 and turn the mode/shutter speed selector to set a shutter speed of $^1/_{1000}$ sec. A red M, for manual mode, now lights up above the shutter speed scale on the right-hand side of the viewfinder and, if you have an X-300s, a red LED flashes next to "1000" to indicate that you have set the shutter speed manually to $^1/_{1000}$ sec. An LED stays lit beside "125". This tells you that the camera's exposure meter considers $^1/_{125}$ sec to be the correct shutter speed, because the exposure value of 13 together with the aperture setting of f/8 allow no other conclusion.

You can now turn the shutter speed selector until only the constantly lit LED next to "125" can be seen, and then release the shutter. The camera then exposes the film for $^1/_{125}$ sec at f/8, and you achieve a correctly-exposed picture. The procedure with an X-700 is exactly the same except that there is no flashing LED to tell you what speed is set on the dial, so you have to remove your eye from the eyepiece in order to set it.

You can also set the aperture ring to another f/number, and the exposure meter will always tell you the correct shutter speed which will match the brightness of the subject, the film speed and the selected aperture. However, if you set the aperture to f/1.7, an upward-pointing arrow will appear above the scale, warning of the danger of overexposure. Why is this warning given? It's quite simple; at an exposure value of 13, an aperture of f/2 (or f/1.7) would require a shutter speed of $^1/_{2000}$ sec, and your camera cannot provide you with this.

This not only sounds complicated, it is complicated. You should confine manual exposure setting to a few circumstances which we will read about in the next chapter. Trust the automatic exposure system of your camera

When the camera is set to automatic, this operating mode is indicated by an "A" in the viewfinder - an LED next to the relevant number shows which shutter speed the camera would select for the chosen aperture setting.

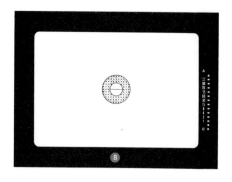

rather than your own judgment - basically, it does the same as you would do only quicker and more efficiently!

Aperture Priority Exposure

With the camera's mode selector set to AUTO (X-300s) or A (X-700), select the aperture, having set the film speed correctly, and the brightness of the subject is measured by the exposure meter. The automatic exposure system now uses the three items of data to compute the correct shutter speed, instantly passing this on to the exposure control, and indicating the correct shutter speed with an LED in the viewfinder. If you now release the shutter, the correct shutter speed will be used - as long as the mode/shutter speed selector is set to AUTO. The whole affair naturally takes much less time than if you do it manually, but that is not the only advantage.

If you set the shutter speed by hand, this will be used for the exposure in accordance with the sequence of shutter speeds; precisely $^1/_{500}$ sec or $^1/_{125}$ sec. However, the lighting conditions do not necessarily alter according to whole exposure stops simply because our photographic

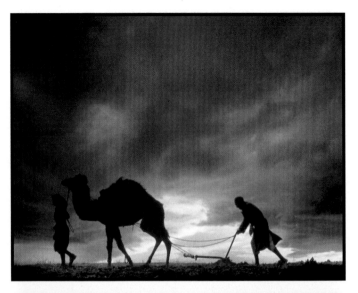

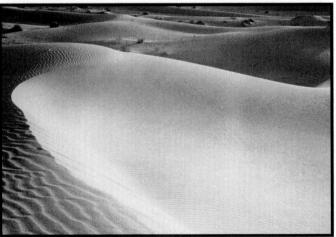

Above: *In order to achieve an unusual atmosphere, no attempt was made to illuminate this counterlit shot. The silhouettes outlined against the break in the clouds show that it is worth waiting for the right moment (Manfred Marte).*
Below: *The picture of the dunes proves that is perfectly possible to take colour photographs using only one colour (Roland Breidenbach).*

Above: *In order to balance shadows and highlights, it is sometimes worth dispensing with the automatic metering and setting shutter speed and aperture by hand - tending towards underexposure in this case (Manfred Marte).*
Below: *What appears at first sight to be a reflection is, in fact, a skillful double-exposure (Dieter Matthes).*

technologists have defined things in this way. Light is continuously variable, and the X-300s and X-700 can also provide continuously variable shutter speeds, when set to aperture priority mode.

The quartz-controlled electronics can start the second shutter blind on its way after precisely $^1/_{478}$ sec, if the light conditions require this, or after $^1/_{437}$ sec. As the electronic commands have to be carried out mechanically, deviations from this theoretical precision can, of course, occur, but they are so slight that exact exposure is guaranteed, if you take into account the exposure latitude of the film.

Programmed Exposure

If you have an X-700, you have a third option for exposure control: the program mode. This is selected by turning the mode selector to **P** and setting the lens to its smallest aperture, which is marked in green. A green **P** will appear in the viewfinder display. The camera will now take complete control of the exposure, selecting and setting not only the correct shutter speed, but also an appropriate aperture. This is the ideal mode for snapshots, since you can use the camera immediately without thinking or having to make any adjustments yourself.

Speed and accuracy are therefore the two reasons why the use of the automatic exposure facility is to be recommended. We will consider the question as to which aperture you should select when we look at the subjects of depth of field, camera shake and composition.

Incorrectly-exposed pictures can occur both in automatic mode and when you set the shutter speed manually, if you rely on the camera's exposure meter for the latter. How come? Isn't your camera as perfect as the salesman so eloquently promised?

The Problematic Exposure

The exposure meter in your X-700 or X-300s does not, of course, know by itself whether a slow or fast shutter speed should be used to expose a particular subject at a selected aperture setting.

The exposure meter is calibrated. A subject which it would regard as ideal would reflect as much light as a grey card with a reflective power of 18%. The exposure meter always makes its suggestions regarding faster or slower shutter speeds in such a way that, to exaggerate, a standard grey picture of this sort is produced in the end.

Subjects which fit the formula are reproduced correctly. But subjects which are too light or too dark are brutally adapted to the calibration setting. The result is an incorrectly-exposed picture and an annoyed photographer.

However, it should be said that the statistically-derived value of 18% reflective power is a very good value. It suits a good 90% of all subjects, quickly ensuring - in combination with the automatic system - very precisely-exposed pictures. Only the remaining 10% of all subjects cannot be accommodated by the exposure meter. Which are these, and what can be done about them?

First of all, it is possible to do something about them, and there are four basic types of subject which do not fit in with the 18% clause, namely:

- very light subjects
- very dark subjects
- small, light subjects against a large, dark background
- small, dark subjects against a large, light background

In order to familiarize you with these difficulties, I would like to go through two examples with you; the other two are analogous and can be left to your imagination.

What happens in your camera when it sees a very light

subject? The exposure meter sees all the light and be-lieves that it's looking at a brightly-lit grey subject with 18% reflective power. In order that the grey subject should come out grey on the film, it sets a fast shutter speed to match the aperture which has been set; the wider the aperture, the faster the shutter speed, as you may remem-ber. The picture clearly shows these efforts by the expo-sure meter; the light area no longer appears brilliant and bright - to use a phrase from washing powder adverts: it looks grey.

The remedy is quite simple. The automatic exposure system has underexposed the light subject, so it seems too dark. In order to look right, more light must be allowed to strike the film, the correct exposure is in fact an overex-posure in terms of the exposure meter's calibration. We will see how this is achieved in a moment.

To take a second case. In front of the large, light area, there is a small, dark subject which is supposed to come out in the picture along with the light surroundings. What happens? The small dark area hardly influences the opin-ion of the exposure meter. Again, it sees a lot of brightness and, accordingly, recommends a fast shutter speed for the selected aperture. This not only causes the light area to come out grey; in order to be correctly exposed the dark main subject requires a relatively slow shutter speed, and what it gets is precisely the opposite. The fast shutter speed leads to a clear underexposure of the main subject, which comes out much too dark, and in extreme cases against a much lighter background, only appears as a silhouette.

Again, the remedy is underexposure with respect to the metered value.

In the same way, you can now work out why an overall dark subject or a small light subject against a dark back-ground require less exposure than the suggested value in order to be correctly exposed.

I can't say here to which extent one must under- or

overexpose. When the values for correct exposure are difficult to determine, even professionals who have been in the business for a long time do not rely simply on experience, but prefer to apply the shotgun method. We shall learn more of this in the next chapter, once we have got your Minolta camera to pass more or less light on to the film than it considers correct.

Solving the Problem of Exposure

Your Minolta camera features TTL (Through The Lens) exposure metering. The exposure metering is carried out through the lens, i.e. with the same angle of view at which the picture is taken. That is the second-best of all solutions (the best is incident light metering, but this is only possible with hand-held exposure meters and is a bit more complicated) as long as the subject conforms to the by now tiresomely familiar 18% grey reflectance.

However, if the angle of view is very wide, a large percentage of sky is often included in the picture, the brightness of which can lead to a shutter speed being set which is too fast. You can avoid this by simply setting a slower shutter speed manually, but that is not always a reliable method because you can quite easily make a wrong assessment.

It is considerably simpler to work out how to use the AE lock/self-timer switch on the right-hand side of the camera. When preparing to take a wide-angle shot of this sort, point the camera down until the proportion of landscape in the viewfinder outweighs the amount of sky. You store the exposure value metered in this way by pressing and holding down the switch. You then raise the camera again to frame the shot as desired and press the shutter release button. As your camera has been well designed, you won't

When the exposure settings are being set manually, this operating mode is indicated by the "M" in the viewfinder; a flashing LED indicates the shutter speed which has been set manually, and a continuously glowing LED shows the shutter speed which the camera would select.

even get your fingers mixed up. The middle finger operates the AE lock/self-timer switch, the index finger the shutter release button.

This technique often leads to success. You always meter the part of the subject which is important, the surroundings will then come out too dark or too light but you have to accept that. When doing this, you can exclude from the metering field, which corresponds with the viewfinder image, the part of the subject which is disturbing the exposure reading. If you have chosen a zoom lens, you can also zoom in to the narrowest angle of view (longest focal length), lock the exposure, zoom back to the original composition and then release the shutter.

If you want to take several shots with different shutter speeds, it is quite worthwhile setting these manually, but after taking a substitute reading in one of the ways described above, and not by rule of thumb. The M in the viewfinder warns you not to forget to switch back to AUTO.

Of course, this method is only possible with subjects in which one part can provide the correct exposure. In the case of very light or very dark subjects, the substitute subject must be found elsewhere; for such cases, one can

carry a standard grey card around, which must be lit by the same light that illuminates the subject.

There are many subjects which do not fall directly into the category of exposure problems, but which can only be photographed successfully by using an exposure deviating somewhat from the norm. Autumn leaves shot through with sunlight, for instance, appear very light and airy if slightly overexposed, and the colours become full and saturated when slightly underexposed. However, one should only adjust the exposure very slightly here, otherwise the picture simply comes out overexposed rather than airy.

You can also cause the camera to give more or less exposure by using the exposure compensation control of the X-700, or resetting the film speed of the X-300s. Doubling the film speed, or setting the compensation dial to "-1", will halve the exposure, and vice versa. The X-700 offers up to two stops compensation, over or under, in half-stop increments. Each click-stop on the X-300s film speed dial represents an exposure adjustment of a third of a stop.

Your Minolta camera offers the means of achieving correct exposure, even under difficult conditions, on its own, but there are other methods, independent of the camera, such as lighting or the use of neutral density filters, which we will meet in the next chapter.

Aids to Correct Exposure

If one part of the subject is dark and the other light, this doesn't necessarily pose a problem. If the contrast is not too high or if the maximum difference between the light area and the dark area is not too great, the picture may turn out to be worth looking at - but not necessarily good.

You won't be able to even out the contrast using the

built-in features of your camera; this will require other measures. If you overexpose, in order to correctly expose a dark subject in front of a light background, the background will come out too light. Another solution in the case of a dark subject in front of a light background is to simply bring more light onto the dark subject by using a flashgun, for instance. What other ways are there of putting a bit of extra light on the subject? There is a wide range of options, which, however, all involve reflecting existing light onto the subject. For this purpose, you can use mirrors, expanded polystyrene sheets, a white card or sheet, or aluminium foil.

A second way of evening out the contrast is offered by the neutral density filter, which is not only available in a completely tinted version. They are also available as graduated filters, where the grey tint is reduced in density from one side to the other, until it is virtually reduced to zero. With other graduated filters, the grey tint gradually increases or decreases from the outer edge towards the centre, forming a transparent centre spot or a transparent border.

Again, these filters are not only available as round filters which must be screwed into the filter thread on the front of the lens, where they lock tightly into place; they are also available in rectangular form mounted in front of the lens in special filter holders. And these are good because they are large enough for you to be able to slide them back and forth in front of the lens.

This makes it possible to do the following. You may wish, for example, to take a picture of your friend, who is wearing dark clothing, in front of a bright window. Now your friend is also sitting in her own shadow and the contrast is fairly high. You can measure this by moving closer and metering the exposure in such a way that the dark clothing fills the whole viewfinder. The result at f/5.6 is $^1/_{30}$ sec. Now meter the background on its own. Result at f/5.6 is $^1/_{125}$ sec. If you now expose at $^1/_{30}$ sec, you may

get a perfect picture of your friend, but the background, the blue sky with the fluffy white clouds, will come out four times too light. In this case, you will be in luck if you have a neutral grey graduated filter which is dark around the edge and becomes lighter towards the centre. You mount this filter, complete with holder, in front of the lens, and adjust its position until your friend is sitting right in the clear spot, while the sky is covered by the darker zone. If the filter has a factor of 4x, the grey zone blocks out just sufficient light so that you can take the shot at f/5.6 with $^1/_{30}$ sec and expose both parts of the subject correctly. If you only have an ND 2x filter that is still better than nothing. You can always increase the film speed setting by a third of a stop, which has the effect of underexposing your friend by a third of a stop - which actually improves the colours - and overexposing the sky by two-thirds of a stop, which is quite acceptable.

You can do the same with all types of subjects as long as you have the right neutral density filter. Of course, that isn't something you have to worry about immediately. You will still often achieve better pictures by simply under- or overexposing than if you just rely on the automatic exposure. But once you have had your first taste, you are sure to enjoy using this sort of technique in order be able to deal with even more situations.

Films, Films, Films

Besides camera, batteries and lens, the film is the fourth indispensible factor in taking pictures. But which film should you use in your Minolta camera? I don't mean which make, I mean which type of film? There are three types to choose from:

- black-and-white negative films
- colour negative films
- colour transparency films

Of course, there are also black-and-white transparency films, infrared films for colour and black-and-white, instant transparency films and litho films, but they are not necessarily suitable if you basically want to take pictures for the fun of it, which is why I am leaving them aside for the time being. What are the advantages of the three types of film named above?

Nowadays, using black-and-white negative film means that you will have to do everything for yourself. There are, indeed, laboratories which develop black-and-white films and produce enlargements from black-and-white negatives, but these are thin on the ground, and good quality work, particularly special directions on enlarging, costs money.

So anyone opting for black-and-white is also opting at the same time for their own darkroom. This isn't as tragic as you might imagine. It doesn't take long to learn how to develop a film, or how to produce good pictures with a simple enlarger. You will eventually acquire more specialized skills and at some point you will find that this all becomes second nature - even if you have no particular technical aptitude and always call a mechanic when you need to change a spark plug in your car.

There is something else involved in the decision to go for black-and-white photography which is much more difficult than the darkroom work. Anyone taking black-and-white pictures must see things in a different way to someone taking colour photographs. Blue and green can be clearly distinguished from one another in a colour picture - in black and white pictures blue and green are two grey tones which are often very similar to one another.

If you wish to be successful in black-and-white photography, you must learn to look beyond colours and recog-

nize the structures which are hidden behind; you must learn to detect the graphic elements. You should also accustom yourself to pay attention to light and shade, which can add the finishing touch to a black-and-white picture.

Whereas in a black-and-white negative - the basis for an enlargement - only the brightness values are reversed and black appears as white and white as black, with colour negative film, the colour values are also reversed. Blue is yellow in the negative but also only in theory. The entire film is coloured by a mask which provides better colour separation and changes all the colours in the negative even further.

So while it is quite difficult to judge even a black-and-white negative correctly, it is virtually impossible, without a great deal of experience, to tell from a colour negative whether it will produce a good picture or not.

But there are other reasons why you would not be advised to set up your own colour darkroom straight away. In order to achieve correctly-processed colour photographs, colour casts must be precisely identified and filtered, the times for the individual processing stages must be followed very exactly, and the processing chemicals must also be kept at exactly the right temperatures. This would all pose problems for anyone without any darkroom experience, quite apart from the fact that a colour enlarger is not exactly cheap.

In any case, it is not necessary to develop colour films yourself; you can leave that to a laboratory, which will normally make a print from each negative at the same time. This is done, in large laboratories, by automatic enlargers which - like the exposure meter of your X-700 or X-300s - are calibrated for standard subjects. These printers even incorporate exception rules in their programmes. They do produce some pictures with colour casts but these can usually be reprinted satisfactorily if you return them.

Which leaves us with the third film type, the colour transparency film. With these films, all you can do yourself is expose them, rewind them and send them to the lab. They are then returned as colour slides which you can look at straight away without any further enlarging. Nobody sees the negative stage of a slide film. The reversed brightness and colour values are reversed again during the actual developing, which is why slide films are often also referred to as reversal films.

Like black-and-white and colour negatives, colour slides only measure 24x36mm (somewhat larger, of course, including the sprocket holes), and in the eyes of some photographers, this represents their main disadvantage. They say that you need a screen and a slide projector in order to appreciate these transparencies properly.

This is both true and untrue. In order to appreciate slides, you require a slide projector, which (with all the extras) doesn't really cost a fortune any more, and a screen - it doesn't have to be one which is permanently anchored to the ceiling, which rolls up automatically at the touch of a button or measures 3x3m. A normal 125x125cm screen will be adequate, matt white if you have a wide room, beaded if the viewer is sitting in a narrow room close to the optical axis of the projector's lens, or silver if it is difficult to darken the projection room properly.

Once you have a projector and screen, there is nothing to stand in the way of your enjoyment, and it is always fascinating to see a brilliantly glowing picture which is more than one metre wide, and this fascination increases with the size of the picture.

So true enjoyment requires a projector and screen, but it is just as easy to look at slides as it is to look through an album. There is a wide range of table-top slide viewers with built-in screens which blow the slide up to a size of between 15 and 30cm across, i.e. still larger than a picture in an album, and more arresting because of the power of the light.

But in recommending slide film, I don't want to put you off paper prints and albums. It is possible to produce excellent prints from transparencies - which, you will say, are dearer than comparable prints from negatives.

This is true, if you compare the price per picture. But looked at in another way, the slide film represents much better value. Processing and mounting are included in the price of certain slide films, although with other makes of film these stages are extra. Once framed, the slides are ready for use and can be viewed; even small slide viewers give a good impression of the picture.

This is the moment when you decide which slides you want to have prints made from - you can judge the colour of a slide just as easily as you can the sharpness.

To spare yourself disappointment, you should examine the slide against a normally-lit white sheet of paper. The degree of contrast which you now see corresponds approximately to the contrast you will find in the print. The reason for this precaution - slide film can reproduce much greater contrast than colour printing paper, and can produce finer differentiation. This all comes across in the illuminated, glowing slide but tends to be lost in the paper print. However, you will see that in many cases, where the shot involved no high contrasts, the print brings out everything that was on the slide.

One qualification should be made. The picture ratio of a 35mm slide is 2:3, which does not correspond to that of the paper. So part of the original picture is always lost during enlargement. You should be prepared to accept the fact that the picture might get cropped along the most important side. Then, in the event that part of the lawn is cut out rather than your son's haircut, you will be all the more pleasantly surprised.

If you opt for slides, you should, at the same time, also give some thought to the question of storage and space. Keeping all your slides in magazines, ready for projection, is, in the first place, a method which takes up a lot of space,

and secondly - there are many pictures which you will seldom bother to look at anyway. Of course there is nothing to be said against storing those slides which you look at more frequently (complete holiday series, series from walks or family celebrations) in the magazine. For the other slides, which you just keep for the sake of it, I would recommend transparent file sheets. Plastic sheets with little pockets holding a total of 24 slides are available from a number of manufacturers. You can store these sheets in ring files - arranged according to subject - and use them to put together a slide show whenever you want to.

If you decide to go for paper prints - either exclusively or together with slides - you should make sure from the start that you do not adopt the "S" system of storage. "S" standing for shoebox. The larger the collection of pictures grows, the more difficult it becomes to motivate yourself to put them in order, and the more difficult it is to sort out the pictures according to particular events or periods, which is fatal in the case of pictures of children. Believe me - I speak from experience.

Get yourself some albums straight away, a separate one for different events (holiday in Majorca, family gathering 1980, hiking with the Robinsons) and avoid sticking in prints at random. Pictures which don't necessarily belong to a particular group - close-ups of flowers and insects for example - can be put in an album of their own and added to over the years.

You should also pay attention to the layout of the album. Don't simply stick the photos in next to one another - create contrasts as well; a large print on the left-hand page, six small ones of the same format on the right, opposite; stick three pictures in straight and put the fourth one in at an odd angle - you have enough imagination to work out other contrasts for yourself.

Don't regard it as silly to include admission tickets, train and bus tickets or sections from maps, and feel free to write in your impressions, too. If you are ashamed of your

scrawling handwriting, use a typewriter and paste in the text next to the pictures. This not only improves legibility, but lends the album a documentary character.

One more tip on the subject of albums. The format of a slide is fixed; 24x36mm, picture ratio 2:3. With prints, you need not leave things the way they are. Pick up the craft knife and cut off any annoying areas. Make vertical formats into squares or horizontal formats and vice versa, and don't be afraid to try novel formats (without overdoing it). A heart-shaped photo of the bride and groom ... if you find that corny, don't do it, but if you do it, don't worry about what other people say.

And whilst I'm on the subject. If you opt for slides, you should approach their presentation in the same way as when putting together an album.

However, you should avoid contrasts here. Change from vertical to horizontal format as seldom as possible, because the effect is irritating. In holiday series, don't keep changing back and forth between blue skies and rain clouds, even if this is chronologically accurate. Try and order them in a different way, and put the rainy shots together, if that makes thematic sense. Throw all those slides which turned out badly into the waste bin or, if they are of personal value, keep them in a private collection. Your guests aren't interested in whether the slide is unsharp because you were sitting on a camel and couldn't spare both hands for taking the picture. The difficulties involved in taking the picture may interest them as an additional piece of information about an excellent shot - but the shaky pyramid is an insult to the eye.

As a slide photographer, you need not stick to the rule that one should never show more than a hundred slides. When applied generally, that is nonsense. If your guests were with you on the hiking tour, they will be happy to look at a hundred and fifty interesting slides which bring back memories and encourage anecdotes. But if your guests know Paris inside-out, perhaps you should just show thirty

to fifty good, selected slides to avoid boring them.

Following this digression on the subject of prints and slides, we shall now return to the subject of film, or rather film speed.

The Speed of the Film

The subject of film speed has cropped up time and again and we now know the following:

The film speed states the amount of light which a film requires for correct exposure. It is set by the film speed ring on your Minolta camera. It can be used for exposure compensation and is calibrated in one-third stop increments.

That is a start, but there is still quite a bit more to be explained.

It is true that the amount of light which a film requires is defined by the film speed, but that is a little like the flowers in the window box. Some require the correct ration of water punctually or else their leaves will droop, others don't mind a long thirsty period and can withstand an attempt to drown them. Among films, there are also those which are sticklers for accuracy, notably slide films, and professional ones in particular. Negative films are not so fussy in this respect, their exposure latitude compensates for slight over- or underexposure. So in the case of negative films, altering the film speed setting by only small amounts for purposes of compensation is not worthwhile, as a third of a stop lies well within the exposure latitude. As the exposure is further balanced during printing, you would get two identical prints despite the one third of a stop difference. Exposure compensation for negative film should therefore usually be made in full stops.

With slide films, the one third of a stop does has a visible

effect, so you should consider carefully which film speed you set on your camera. You will now say, the one on the film carton, of course, but that is not always the best in every case. You should therefore calibrate your camera to match your film. We shall assume that, having tried out several makes of film, you prefer XY film. You should now, if your budget allows, buy eleven of these films with the same emulsion number (they will react the same under the same conditions) and put ten in the fridge. This is the best place to store film because high temperatures can affect quality. Load the eleventh film into your Minolta camera, set the film speed as stated on the carton and find a subject which features a lot of colours and which is not too high in contrast, that is to say which displays no excessive difference in brightness between the light and dark areas. Take a picture of this subject with automatic shutter speed selection at the recommended film speed setting, then take a second shot at a film speed setting one third of a stop below the nominal rating, and so on in one-third stop increments until you are exposing the film at a speed setting two stops below the recommended one. After taking the first seven shots, do the same, in one-third stop increments, until you are exposing at a film speed setting two stops above the nominal speed. You can shoot off the rest of the film on subjects which strike you as photogenic, and here too, of course, you can play around with over- and underexposure by one- or two-thirds of a stop. After processing you can compare the results.

The first picture is the initial shot against which you measure the others. If you prefer the second or third picture with its saturated colours, you know that you should expose this film by one- or two-thirds of a stop less than stated. If you prefer the seventh or eighth picture, you should expose this film by one or two stops more in order to achieve the lighter colours.

The other exposures in the first series will be much too dark or much too pale, but these pictures will give you an

impression of the effect of the different degrees of under- or overexposure.

Now we shall look at the individual film speed settings. The series of film speeds used has intervals equivalent to one-third stops, typically 12, 16, 25, 32, 40, 50, 64, 80, 100 and so forth. The significance of these numbers is that a film with twice the speed number of another requires only half the exposure - one stop less.

ISO stands for International Standards Organisation and the numbers replace the older and obsolete national standards, American and German, although they have precisely the same significance. ISO film speeds are properly written thus - ISO 100/21°. The number before the oblique stroke is part of an arithmetic series of numbers in which twice the number means twice the speed and the need for only half the exposure. The number after the oblique stroke is part of a logarithmic series in which an increase of 3° means doubling the speed. The degree sign is just to indicate that the speed number is a logarithmic one. The old ASA and DIN speeds have not been changed; they have just been combined to form a single international standard and the numbers have exactly the same values as the numbers in the national standards that have been replaced. An older camera using ASA and DIN speed numbers can be used with ISO speeds without any changes.

Logarithmic speed numbers have an advantage that is gradually becoming apparent. However fast films become, their speed numbers are most unlikely to ever have more than two digits whereas there is perhaps not long to go before we have a film with a speed of ISO 12800/42°! How could such large arithmetic speed numbers be accommodated on camera scales?

In order to avoid confusion, I have included a table which you will also find, in simplified form, on the back of the X-700. The film speeds marked with * are the ones most commonly available.

ISO 12/12° ISO 16/13° ISO 20/14° * ISO 25/15°	Low speed film
ISO 32/16° ISO 40/17° * ISO 50/18° * ISO 64/19° ISO 80/20° * ISO 100/21° ISO 125/22°	Medium speed film
ISO 160/23° * ISO 200/24° ISO 250/25° ISO 320/26° * ISO 400/27° ISO 500/28° ISO 640/29° ISO 800/30°	High speed film
* ISO 1000/31° ISO 1250/32° ISO 1600/33° ISO 2000/34° ISO 2500/35° ISO 3200/36°	Extremely high speed film

As you can see, the table is divided into low speed, medium speed, high speed and extremely high speed films, and you will also see that most of the asterisks can be found in the medium speed range. You can conclude from this that this is not only the group offering the widest available range, but also the group with the widest area of use.

The medium speed films of ISO 100 and ISO 200 should meet all your needs, particularly if you possess a flash unit, a tripod, or both. The colour reproduction of good ISO 100

and 200 films is excellent, the sharpness is perfectly satisfactory and the graininess is so slight as not to be noticeable.

The new generation of high and extremely high speed films are also excellent, but this speed must still be paid for in terms of larger silver halide crystals. Such crystals are the light sensitive material which makes normal photography possible in the first place. The larger the crystals are, the more light-sensitive they are, and the sooner they become visible on the picture. Although the most recent films are an improvement on their predecessors thanks to special techniques in forming the crystals, they are still not all-round films. They should be reserved for those occasions when the use of flash or a tripod is simply not possible, and yet pictures have to be taken.

The slowest slide films of ISO 25 have become rarer and rarer, until now there is only one left, Kodachrome 25. The sharpness of this film is legendary, but one has to depend on extremely good light in order to take hand-held shots.

Films with variable nominal speed ratings have also been available for some time. They are to be found in the very fast speed range, e.g. 800 - 1600 - 3200. Of course, it is not possible to change the speed of the film in the middle of a roll - the whole film must be exposed at one of the speeds available for selection. Even when using normal films, it is possible to work at a film speed setting deviating by one or two stops from the nominal one, that is to say over- or underexposing the film by one or two stops and yet still achieving correct results. The deviation must be marked on the dispatch envelope and on the film cassette, then the otherwise ruined film can be saved by special developing at an extra charge. So you needn't despair if you realize that you have exposed a whole ISO 100 film with the film speed ring of your Minolta X-300 set to ISO 200. This rescue procedure does, however, involve a loss of quality - which is not the case with variable speed films; they provide the same quality at any of the speeds allowed.

Sharpness in Depth

Before we turn to the wide range of lenses offered by Minolta, I would like to explain two terms which we have already come across in an earlier chapter and which will crop up again many times in the course of this chapter. In this section, I will explain about depth of field, and I will deal with perspective in the next one.

Depth of field is a phenomenon which would not exist if we humans had better eyes. But our eyes are the way they are, and they are not capable of distinguishing between points and circles, as long as these circles do not exceed a certain size.

Lenses only reproduce one plane in sharp focus - the one which is focused on. A point on this plane will also be a point in the picture. Points which lie in front of or behind the focusing plane, on the other hand, will be reproduced as circles, and the further away from the focusing plane the point is, the larger the circle will be. But as long as the size of the circle does not exceed 0.25mm, it will still be perceived by the eye as a sharp point.

In addition to the distance, the focal length of the lens also plays a role. The shorter it is, the further away from the focusing plane the point can be before it is reproduced as a circle.

Is it true, then, that the depth of field of wide-angle lenses is greater than that of telephoto lenses? Yes - as long as the distance is the same. At the same distance from the subject, the lens with the shortest focal length has the greatest depth of field - i.e. a 100mm telephoto has a greater depth of field than a 300mm lens. Or, to put it differently, the depth of field is greater in the picture where the subject appears smaller when photographed from the same distance.

This rule is interesting because the converse also applies. If the subject is the same size in two pictures (i.e. if the reproduction ratio is the same), the depth of field is also the same. So if you approach the subject with a wide-

Experimental photos should not simply be regarded as something to do on rainy days - they are a constant challenge to creative photographers. (Klaus D. Homrighausen, above; Michael Studtmann, below).

Above: *The large area of subdued blue is balanced out by the small patch of aggressive red (Silke Hanskammer).*
Below: *If the foreground is included in the picture, this accentuates the depth of the landscape - emphasized by the "blueness" of the distant hills (Wolfgang Mangold).*

Above: *In this shot of a girl engrossed in her play, the view from above provides a direct link between the child and her drawing, and the grey ground is brightened up by the red colouring of the sleeves (Izzet Keribar).*

Below: *In order to bring out detail in the guard's cape, the picture had to be overexposed slightly, which causes the sky to appear too light (Heinz Klaus).*

If you don't feel like searching for a subject, you can always create one yourself (Bernd Walter Gorny, above). The sky need not be a brilliant blue in order to tempt photographers. If the subject includes dark clouds, a slight underexposure can emphasize the atmosphere. (Walter Gaberthuel, below)

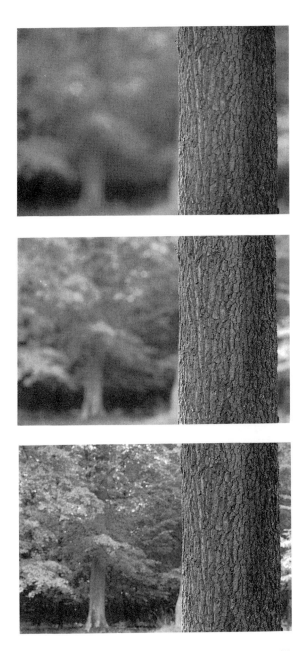

angle lens until it is framed in the same way as through a telephoto lens at longer range, the depth of field is the same, and the wide-angle lens no longer has any advantage in terms of depth of field - as long as the aperture settings are the same.

This rule holds good only for reproduction ratios up to about 1:20. At bigger ratios the short focus lens always has the advantage.

If, in the situation described above (wide-angle close up - telephoto further away, same reproduction ratio), you stop one of the lenses down to f/22 and leave the aperture of the other one wide open, say at f/3.5, then the depth of field of the picture taken with the stopped-down lens will be increased.

All this can be summarized in the following three rules on depth of field:

- The greater the distance, the greater the depth of field (same focal length and aperture!)
- The shorter the focal length, the greater the depth of field (same distance and aperture!)
- The smaller the aperture, the greater the depth of field (same distance and focal length!)

Caption for page 69: If the distance and the focal length remain the same (i.e. the reproduction ratio remains the same) the depth of field is determined by the aperture setting. The more the aperture is stopped down, the greater the range which is brought into sharp focus by the lens. This applies to all lenses - whether wide-angle, telephoto or zoom. In this example, the aperture was stopped down from f/2.8 to f/5.6 and then f/11, which explains the increase in depth of field. In order to keep the subject framed in the same way, and to prevent camera shake, the camera was mounted on a solid three-legged tripod.

Perspective: Objects in Space

A picture is (if one disregards stereo photography) a flat, two-dimensional affair. There is no depth; two things which in reality stand behind one another suddenly stand next to each other. And yet we can usually tell at a glance which object was standing in front of the other. This is made possible by perspective.

Objects which are closer to us appear larger than objects which are further away. This is the case both when seeing normally and looking at a picture. The apparent reduction in size even follows a rule. The reduction in size is proportional to the distance. A two metre high pole which is two metres away from the camera will appear twice as large on the picture as its equally high companion which is stuck into the ground four metres away.

The impression of depth is also conveyed by converging lines. Lines which are parallel in reality seem to run towards each other, converging at the same time on the vanishing point.

Perspective is always there - no matter which lens you use. Whether wide-angle or telephoto, the perspective is the same. It only changes when you change your position. A simple example will show how true this is.

Find a traffic sign which precisely covers a tree when you stand in front of it at a certain distance. Now look through your Minolta X-300s fitted with a standard lens. The traffic sign covers the tree. Mount a lens with a different focal length or use a zoom and look at the subject once more. More of the area surrounding the sign will be seen if you use a wide-angle lens, but it will still cover the tree exactly as before. If a telephoto lens is used, hardly anything will be seen of the area around the sign, which still covers the tree. But if you take a step to the side, you will notice that the branches of the tree are visible at the side of the sign; take a couple more steps to the side and the whole tree is revealed, and as you move towards the sign, it will rise above the tree. Again, it makes no differ-

ence which lens you use.

Although this clearly shows that the perspective remains the same whether you take a shot with a wide-angle lens or a telephoto, as long as your position remains the same, you will also hear the expressions wide-angle perspective and telephoto perspective.

We must distinguish between two types of wide-angle and telephoto perspective. One refers to a perspective which is actually different. Thanks to the wide angle of view of a lens with a short focal length, it is possible to take pictures of large objects, whose nearest part is close to the lens, from very close up. This part is reproduced very large, the point which lies twice as far from the lens is soon reached, and the part of the subject at this point is reproduced only half as big. The regression in depth of the parts of the subject standing behind one another is thus very pronounced, which produces the wide-angle perspective.

In contrast, the same object can only be framed in full from a great distance if a telephoto lens is used. As all the parts of the subject are almost equally distant from the lens, the progressive reduction in size with increasing distance is hardly noticeable, and the objects seem to be close together, producing the flat telephoto perspective.

Even if both photographs are taken from the same position, it is possible to distinguish the wide-angle shot from the telephoto shot. At the same aperture setting, the wide-angle lens produces greater depth of field in any case, but that is of no importance in this context. What is more important is that, because of the wide angle of view, the converging parallels approach the vanishing point from some way off, thus conveying depth. With the narrow angle of view of the telephoto lens, the converging parallels are cropped by the edge of the frame quite close to the vanishing point; this produces the compressed impression of the telephoto shot.

A special example of perspective is represented by foreshortening, which is often, mistakenly, only ascribed to wide-angle shots, and which is, in fact, usually only

clearly noticeable in wide-angle photographs. Foreshortening has the effect that a house, standing firmly on the ground, suddenly seems as if it is about to topple backwards, and the formerly parallel lines converge on one another as if they are going to meet in the sky. Perspective is responsible for this effect - that and the fact that it is possible to photograph entire large objects from close range using a wide-angle lens.

If you want to take a picture of a building, you would normally choose a wide-angle lens in order to get the whole structure into the picture. But if you hold the camera level, you will include a lot of foreground in the shot and only half of the house. So you point the camera and wide-angle lens up, and the lower parts of the building, which are nearer, seem big, whilst the upper parts, being further away, appear smaller. The house leans backwards! However, the house would tip back in just the same way if you were to take the same shot from a hole in the ground using a standard or telephoto lens. Usually, however, one stands further back from buildings when using lenses with longer focal lengths, the camera is pointed almost horizontally, and everything looks normal. The slight foreshortening effect which is still evident is not perceived as seeming unnatural. We also see it in reality to some extent and are therefore accustomed to it.

Is it possible to do anything about extreme foreshortening without working with a standard lens from a greater distance? It is. Either by trying to find a higher camera position, from the stairwell of the building opposite, perhaps, as long as this doesn't disturb anyone, or by using a shift lens which is described later in the section on specialist lenses.

Lenses for the X-300s

Now that a certain amount has been said on the subject of lenses in general, we will turn to the lenses which you can use with your Minolta X-300s. The fact that only Minolta lenses are mentioned does not mean that lenses made by other manufacturers should be avoided. As I said earlier, many of them are just as good as the Minolta lenses, but to review them all would go beyond the scope of this book. In any case, what is said in general about the areas of use, strengths and weaknesses of the different focal lengths naturally also applies to the lenses offered by other manufacturers.

General remarks

Since the introduction of the Minolta 7000, Minolta has had two ranges of lenses on the market, the AF lenses, which can only be used with autofocus cameras, and the MD lenses. The MD lenses have been on the market since the introduction of the Minolta XD-7 which, in its day, was the first SLR camera with automatic shutter speed and aperture control and required appropriate lenses.

The preceding series was called MC lenses, and you may be able to find these going cheap in the second-hand department of your photographic dealer. You can buy these for your Minolta X-300s without any reservations.

You only need stick exclusively to MD lenses if you are using an X-700, which requires MD lenses for program mode. MC lenses can still be used with the X-700, but only in aperture priority or manual mode.

The Minolta lenses are all multi-coated. What good does that do? When light strikes glass, a large part passes through the glass. Part of it, though, is reflected from the interface between glass and air. This light is not only lost for exposure purposes - when reflected off the elements within the lens it scatters inside the camera, affecting the quality of the picture. This percentage of stray light is reduced by coating the surface of the lens with micro-scopically thin layers of various materials (the "coating"), which increases the amount of light getting through and improves picture quality.

There are a few other specialities, such as floating elements, internal focusing and others. But these things lead us too deeply into the area of lens construction. Let's be glad of these inventions which improve our pictures and leave it at that.

All these lenses are precision instruments which should be handled accordingly. They are supplied with two caps which you should always fit whenever the lens is not mounted on the camera. When you fit the lens onto the camera, always put both caps into the same pocket so that you will be able to find them again quickly without having to go through all the pockets in your jacket, shirt, trousers and camera bag. It's bad enough spending half your time looking for your car keys!

However, it is only necessary to use the cap to protect the front of the lens between shots under extremely bad conditions - driving snow or rain, or at sea if the air is full of fine salt water droplets. Nor is it necessary, as is often suggested, to keep a filter permanently on the lens.

If grains of dust or lint collect on the front or back elements of the lens, the best solution is a blower brush, with which you can remove the larger particles. Then you brush the rest away with the grease-free brush and wipe

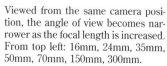

Viewed from the same camera position, the angle of view becomes narrower as the focal length is increased. From top left: 16mm, 24mm, 35mm, 50mm, 70mm, 150mm, 300mm.

the surface of the lens clean with a soft, lint-free cloth or a special lens-cleaning tissue, after first breathing on the lens.

Nor are fingerprints grounds for panic and these happen to everyone sometime. You should breathe on the lens and wipe it clean with a cotton cloth or a special lens-cleaning tissue - if necessary, you can also use lens cleaning fluid. However, you shouldn't use this directly on the lens, you should just dampen the cleaning cloth with it.

Otherwise, Minolta lenses are easy to take care of. They don't need an oil change, and only if you do a lot of photography should you send the lens, plus camera, to the customer service centre, every once in a while. For the average amateur photographer, however, this precautionary measure is only necessary every three to five years.

Note: Lenses which no longer appear in the official Minolta catalogue are identified with an * in the interests of clarity.

Fisheyes

Let's begin this review of the Minolta range of lenses, with the fisheye lenses. These were not developed with amateur photographers in mind. They were originally used for technical and scientific purposes. Because of their extremely wide angle of view of 180°, these lenses see everything which is in front of them. So, using one of these lenses, it is possible to take a picture which includes the whole of the sky, from horizon to horizon. This quality made fisheyes indispensible for security tasks, until they fell into the hands of creative photographers. Nothing was safe from the fisheye, until this fashion, like all other fashions, went out of style. Since then, fisheyes have been

used by photographers wherever their special capabilities are required, or where they improve the picture.

Minolta offer two fisheyes. The MD 7.5mm,f/4* and the 16mm,f/2.8.

Both lenses naturally have an angle of view of 180° but only the lens with the shorter focal length uses this fully to create an image on the film. The 7.5mm lens only forms a circular image of around 23mm in diameter on the 35mm slide or negative - the margins are not exposed. The 16mm lens, on the other hand, achieves the giant angle of view across the diagonals of the 35mm format, covering the whole area of the slide or negative with an image.

Though the advantage of the fisheye's wide angle of view cannot be ignored, nor, on the other hand, can its disadvantage. All straight lines which don't pass through the centre of the picture are curved outwards, and this barrel-like distortion becomes more pronounced the closer the lines lie to the edge of the frame. In the case of the short MD 7.5mm,f/4 fisheye, this goes so far that the edge of the picture itself becomes a circle.

Even if you are unlikely to rush straight out and buy one of these lenses for your X-300s or X-700, I would like to say a little about how these exotic lenses should best be used.

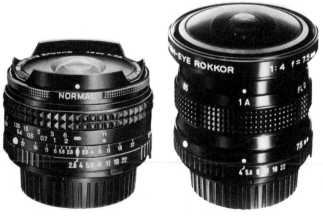

Minolta MD-Fisheye 16mm,f/2.8 Minolta MD-Fisheye 7.5mm, f/4*

The first piece of advice which anyone who has ever worked with a fisheye will give you is, "you can have too much of a good thing". Indeed, anyone who uses a fisheye on anything which comes before his camera, irrespective of subject, will have the pleasure of seeing viewers react with astonishment to the pictures. But just as he is enjoying the "oohs" and "aahs", he will suddenly start to hear comments of a different sort unless the audience are part of the family, in which case they are obliged to react in a positive way. These comments will run along the lines of "not another frog-eye, or whatever the thing's called". Because - let's be honest - in the field of amateur photography, the fisheye shot is a gimmick used to liven up a slide show or album. But a gimmick wears thin very quickly if used too often. However, anyone who has used a fisheye lens will know that this advice will fall on deaf ears at first. The temptation to shoot every subject imaginable in this way is too overpowering. It may be that you are the exception who, on acquiring a fisheye lens, only uses it on 60% of his next film, rather than on all of it.

You should take the second piece of advice to heart. Be over-critical when examining the picture in the viewfinder. As you know, the viewfinder image shows you exactly what will appear in the final picture. The huge angle of view not only captures the subject which you have chosen, it includes everything which is going on in front of your camera. But with the 7.5mm fisheye in particular, this can include the photographer's paunch or chest! You only experience difficulties of this sort with the rather longer 16mm lens if you point the camera downwards.

The third piece of advice with regard to the use of fisheye lenses concerns the horizon. It only runs straight, in a seascape or flat landscape shot, if it passes exactly through the centre of the picture. If you tilt the camera upwards, the horizon bends down in the middle, giving the earth the appearance of a dish. If you point your camera downwards, the horizon bulges upwards, turning the

earth into a ball. In the mountains, where the horizon is already broken by the jagged peaks, this problem is not quite so evident. Whereas a symmetrical composition with the horizon in the middle of the picture should normally be avoided - this tends to look unimaginative - in the case of landscape shots taken with a fisheye lens I would almost always advise you to position the horizon in the centre of the picture. Otherwise, the effect of the curved horizon can become rather tiresome if used too often; fisheye shots with a straight horizon, on the other hand, tend to be less boring. The huge sky and the impression of immense depth dominate the picture in a spectacular way.

Fourth piece of advice. Consider which subjects are suitable for your fisheye lens. Subjects which consist largely of straight lines are usually eye-catchers because they are distorted in an unusual way which is novel to many people. Then, again, there are subjects which are, in themselves, broken and asymmetrical. These are not affected quite so much by the fisheye's distorted view of the world, but the very wide angle of view makes them interesting and fascinating. This group of subjects includes, for instance, shots looking up at sheer cliff faces or balls of tumbleweed in the streets of a wild west ghost town. In this respect, it is vital that the important part of the subject is suitable for the fisheye lens. Anything happening in the background will come out so small on the slide that it will not interfere with the effect of the picture.

In conclusion, one more thing. There is no subject which cannot be photographed with a fisheye lens. As long as the effect is not over used, anything which benefits from the interesting distortions can become a subject for the fisheye. But, again, remember the first piece of advice.

The Lines remain Straight - Extreme Wide-angle

There are lenses featuring a somewhat longer focal length than the fisheyes which are known as extreme wide-angle lenses, two of which are also to be found in the Minolta range, the MD 17mm,f4 and the MD 20mm,f/2.8.

With angles of view of 104° (17mm) and 94° (20mm), they cover noticeably less of the subject than the fisheyes, but, on the other hand, normality is restored to the photographic world. Straight lines come out straight, irrespective of where and how they run through the picture.

Both of these wide-angle lenses display an immense depth of field which, when the lens is stopped down to f/22, reaches from 62cm to infinity (20mm) or even from 47cm to infinity (17mm).

Both the wide angle of view and the great depth of field have their advantages, but there are also disadvantages.

The wide angle of view makes it possible to include the whole of large subjects in the shot even at close range. So extreme wide-angle lenses are useful in tight situations where you, as a photographer, don't have many opportunities of distancing yourself from the subject. This is the main point in favour of the wide-angle lenses - but it is a mistake to add an extreme wide-angle lens to your equipment for this reason alone.

Extreme wide-angle lenses are also creative lenses. In landscape photography in particular, they convey an impression of expansive depth. Depending on how you position the horizon, the sky can be accentuated heavily, which is not only to be recommended on days of brilliant sunshine under an immaculate blue sky. When thunder or rain clouds stretch to the horizon, turning the sky into a churned-up "hanging ocean", an extreme wide-angle lens, pointed slightly upwards, is exactly the right eye for your camera.

If you want to show the endless space in the landscape,

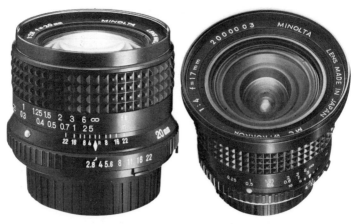

Minolta MD 20 mm,f/2.8 Minolta MD 17mm,f/4*

you should position the horizon in the upper third of the frame. The wide angle of view then brings the close foreground into the picture and, because of the great depth of field, this will come out as sharp as the background, even with a medium aperture.

A wide angle of view should be avoided when taking portraits, unless you want to annoy someone with a photographic caricature. Everything which is very close to the lens will appear outsize in comparison with parts of the subject which are further away from the camera. When taking a frontal portrait, the nose, which is closest to the lens, becomes huge, while the ears come out surprisingly small, protruding from a curiously-shaped oval object which bears only a remote resemblance to a face. Of course you can also use this effect in a positive way, as a joke, by asking your subject to stretch out their hand towards the lens, or, if they are stretched out comfortably on a warm, sandy beach, you can photograph them from a position close to their feet. The size of the hand and the feet, which are very close to the lens, will be exaggerated, and, in the first example, the rest of the person will seem so far behind the hand as to make the relationship seem scarcely credible. In the second instance, an apparently

endless body stretches away behind the huge feet to the horizon.

And now the disadvantages associated with the wide angle of view and the great depth of field. On the one hand - unless you want to take sky-dominated shots all the time - the foreground can pose a problem. Either a barren expanse stretches out in front of the building you are photographing, or the foreground is strewn with rubbish and lost tourists! This can be remedied with much patience by choosing a position from which it is possible to take a picture of the subject with a proper foreground, or you can wait until nobody is in the picture who doesn't belong there. As regards altering your position, it is often enough to squat down and point the camera slightly upwards when taking the picture. A tripod can be useful when trying to deal with floods of tourists. The trick is quite simple. Place the camera on the tripod, select an aperture which allows the slowest possible shutter speed ($^1/_8$ sec or slower) and use the self-timer to operate the shutter. This prevents the camera being shaken when the shutter release button is pressed, causing vibrations which can take effect during the actual exposure. In this case, it is also a good idea to use ND filters (not grey graduated filters) which block out light, and it can also be worthwhile using the "B" setting. During the long exposure time, the building remains standing still, whereas the tourists do not. They keep moving about appearing as vague forms which makes the picture more interesting, rather than spoiling it. It is, of course, important that the actual subject does not move - and this can be a person standing engrossed in front of a shop window amidst hectic movement.

Difficult foregrounds and annoying elements in the composition are not the only disadvantages of the wide angle of view. It also means, in the case of landscape shots, that there is often a large area of sky in the picture, and frequently the sun is also included. This leads to problems in achieving the correct exposure, which can be overcome

by using a neutral density filter or through controlled overexposure. If you are very concerned about producing a picture which is 100% successful, you should not be frugal in using up film in this situation and rather than taking one overexposed shot, you should take a small series, varying the degree of overexposure between each shot by a third of a stop. This shotgun method is used even by professionals in order to be on the safe side though they can probably better afford the increased amount of film used more than the average amateur who has to pay for it out of a tight budget.

And the final disadvantage of the extreme wide-angle. It encourages a tendency to take architectural shots from close range, which leads to the foreshortening effect mentioned earlier.

The Normal Wide-angle

You will probably not consider the acquisition of fisheyes and extreme wide-angle lenses until later. You will more than likely take your first pictures with a wider angle of view than that offered by the standard lens, using a 35mm, 28mm or perhaps a 24mm lens, although this last focal length already borders on extreme wide-angle.

In my opinion, the 35mm lens, with its 63° angle of view, is the ideal lens, because it produces pictures which approximately correspond to what we see with the naked eye. The severe perspective which characterizes extreme wide-angle lenses is not so apparent with a focal length of 35mm, while the depth of field is considerably greater than that achieved with a 50mm lens.

With an angle of view of 75°, the 28mm is the first true wide-angle lens, having displaced the 35mm lens from this position over the last few years. This is probably due, in part, to the fact that most compact 35mm viewfinder

cameras are fitted with 35mm lenses and that this sort of shot is seen as normal. As with the 35mm lens, the exaggerated perspective is not very apparent with the 28mm lens, and the depth of field is already considerable.

Both lenses are ideally suited to reportage because they allow quick shots to be taken even under cramped conditions, because they show the world as the eye perceives it and because both lenses can be set for taking snapshots. This makes use of the extensive depth of field and the fact that the subject is not reduced too much in size.

If there is enough light, the 35mm can be stopped down to f/11, or the 28mm can be stopped down to f/8, and if the focus is set to a range of 5m, everything at a distance of between 2m and infinity will come out sharp in the picture. So all you have to do is raise the camera and press the button. This method is just as quick as autofocus, and more sure, because with AF cameras, there is always the danger that the camera will not be able to cope with the subject, and will ask the photographer to focus manually.

I have excluded the 24mm lens from this group. The pictures produced can often be recognized by the exaggerated perspective. Nor is it necessarily to be recommended as a snapshot lens. Although it does offer the greatest depth of field of the three lenses, details come out very small in the picture.

All three wide-angle lenses are, of course, useful in allowing pictures to be taken even under cramped conditions, but that is not all. The wide-angle lenses can be used to take overall views which are then supplemented by detail shots using a telephoto lens. All three focal lengths introduce a feeling of depth and space into a picture, particularly the 24mm with its wider angle of view.

The 35mm, 28mm and 24mm lenses are also in their element when taking architectural shots - the 24mm has the greatest tendency to produce a clearly foreshortened effect, but on the other hand it allows you to get a whole cathedral into the shot, which might be difficult with the two other focal lengths.

The Minolta wide-angle lenses are also suitable for close-up photography; the shortest focusing distances are around 30cm or 25cm in the case of the 24mm lens. That may only lead to maximum reproduction ratios of around 1:6 to 1:7, but that's a start at least. At these shortest distance settings, the wide-angles are also very suitable for table-top shots of model landscapes; the still considerable depth of field prevents sections of the models from coming out blurred, and the wide angle lends the pictures more depth than can be achieved with corresponding telephoto shots.

Whereas the fisheyes and extreme wide-angles are each only available in one version, of the wide-angle

Minolta MD 24 mm,f/2.8

Minolta MD 35mm,f/2.8

Minolta MD 28mm,f/2.8

Minolta MD 28 mm,f/2*

lenses, only the MD 24mm,f/2.8 is a loner. The two other focal lengths are both available in three versions.

You can choose between three 28mm lenses, the MD 28mm,f/2*, the MD 28mm,f/2.8 and the MD 28mm,f/3.5*. The main difference is in the speed of the different versions. I have already said a few things about the advantages and disadvantages of faster lenses. The optical structure of the three variants differs - the slower the lens, the more simple the construction - but the performance of the faster models is not all that much better.

If you decide to go for the MD 28mm,f/2 model, you should bear in mind that you will have to carry around 100g or so more than your colleague with the 28mm,f/3.5 lens - the size is not of decisive importance when deciding on which lens to buy, as there will be plenty of space in a good universal bag.

Anyone opting for the 35mm wide-angle lens has only two variants to choose from, the MD 35mm,f/1.8* with eight elements in five groups and the MD 35mm,f/2.8. There is a weight difference between the two of 70g in favour of the latter.

The Underrated All-rounder - Standard Lenses

The points in favour of and against normal or standard lenses have already been discussed earlier. As you know, the standard lens is not a useless or even boring lens, nor, on the other hand, is there anything to be said against a zoom lens which includes a focal length of 50mm.

Minolta offer four lenses with a fixed focal length of 50mm: the MD 50mm,f/1.2*, the MD 50mm,f/1.4, the MD 50mm,f/1.7 and the MD 50mm,f/2*.

There is a difference of one and a half stops between the fastest lens of this group and the slowest, which is to say

Minolta MD 50mm,f/2* Minolta MD 50mm,f/1.7

that, with the very fast 50mm,f/1.2 you can still take fairly steady hand-held shots at $^1/_{30}$ sec, when the automatic exposure system would set a shutter speed of between $^1/_8$ and $^1/_{15}$ sec for the MD 50mm,f/2 at maximum aperture almost certainly resulting in camera shake.

However, there is a big contrast in price between these two lenses. The difference in weight of around 150g does not seem so serious at first, until you consider that the MD 28mm,f/3.5 only weighs around 170g.

Short Telephoto Lenses - Only for Portraits?

There is a small group associated with the 50mm standard lenses which consists of only two lenses. These are the MD 85mm,f/2 and the MD 100mm,f/2.5 with angles of view of 29° and 24° respectively.

Both bring rather less of the subject onto the film than the standard lens, and both fall into the category of portrait telephotos. Of course they are not solely limited to the field of portrait photography but there are good reasons for this general classification.

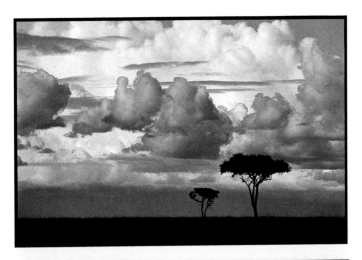

Clouds make a fascinating subject - as do trees. Both occur in a variety of forms, and can be photographed from such a variety of angles that it would be a pity to settle for this one picture. Whole collections can be built up from these two subjects.

Both of these pictures work because the face is not positioned in the centre of the frame. The asymmetrical structure introduces an element of visual tension into the picture. The pictures are made more relaxed through the skillful use of an umbrella as a background, with the spokes converging on the head, and by the super-imposed double-exposure background which lends the photo the character of a drawing. (Ulrich Wagner, above; Manfred Zoller, below).

When taking pictures of people, it is important that the photographer finds out about their customs and traditions, in order to avoid breaking taboos. "Shooting" people photographically from a hidden position is a sign of bad manners. An interest in the people in front of the camera is, in any case, essential when taking portraits. (Siegfried Leucht, above; Hans Repelnig, below).

Above: *The use of a diffuser lends a soft and friendly atmosphere to pictures of children. (Lauritzen Preben)*
Below: *Camera shake is usually the enemy of the successful picture. Sometimes, though, moving the camera during the exposure adds a special touch to the picture - for example, when the camera is rotated around the optical axis using a special accessory. (Izzet Keribar)*

With a focal length of 90mm, a human face will fill the frame of a 35mm slide at a range which produces very natural perspective. Remember: A portrait taken with the 35mm lens which fills the frame in the same way would be a caricature with a big nose, and a 35mm shot with the right perspective would no longer be a portrait!

But not only is the reproduction pleasing, the process of taking the picture is more agreeable with a lens which has a somewhat longer focal length, particularly for the victim. You can take pictures from a distance which stops the person being photographed from feeling intimidated or pushed into a corner.

And the 85mm and 100mm telephotos have another advantage. At portrait range, the depth of field is very shallow at maximum aperture, even at f/11 it only reaches from around 1.40m to 1.60m with the 85mm and is another 5cm shallower with the 100mm lens. That means that when you focus exactly on the eyes (they must be in sharp focus in a portrait) the whole face is in focus, but the background which is one or two metres away can be a total muddle - it is out of focus and will not disturb the picture. Working with selective focus is therefore easier with these lenses.

As you can see, both lenses deserve to be called portrait lenses, but they can do more.

Even the short telephoto lenses save you some trouble. You can take pictures from a greater distance than with a standard or wide-angle lens and get the same amount of the subject into the picture. You can also pick out details in a subject to include in a slide show along with overall wide-angle shots, which is at least as important.

The flat, compressed perspective of the telephotos is already evident with these two lenses, if not very strongly.

As regards weight, they are almost equal, and no difference can be noticed in the reproduction perform-ance. The decision in favour of one lens or the other is therefore a question of taste, bearing in mind that the difference in speed of around a third of a stop is of no great

significance for available light photography and the greater speed of the 85mm telephoto scarcely brings any advantage once the light starts to go.

The Intermediate Solution - Medium Telephoto

The next longest focal length after 100mm is provided by a 135mm lens. Minolta offer three of this type, the MD 135mm,f/2*, the MD 135mm,f/2.8 and the MD 135mm,f/3.5*.

The 135mm lenses were, for a long time, the most popular standard telephotos for amateurs, but were overtaken in this role by the 200mm lenses and also, more recently, by the 70-210mm zooms. Not exactly a proper long telephoto lens, yet no longer a proper portrait lens, the 135mm falls between two stools in a way, but is nevertheless an interesting lens as long as you are not too concerned with taking shots at long distances, as is necessary in most cases for wildlife or sport photography.

But if you are interested in taking snapshots, a 135mm telephoto can be very useful. However, you can't rely on the virtually automatic sharpness of a snapshot setting

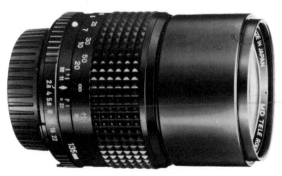

Minolta MD 135mm,f/2.8

Minolta MD 135mm,f/3.5*

unless you can stop down to at least f/16. So you need a sure eye for focusing and must also know exactly in which direction you have to turn the focusing ring in order to achieve the desired result. But that comes with practice, and you can learn to focus quickly. The following tip may help. If the upper part of the subject in the split image rangefinder is displaced to the right in relation to the lower half i.e. the focus has been set to too short a distance, then you must turn the focusing ring to the left. Or more generally - you must turn the focusing ring in the direction in which the part of the subject in the upper half of the split image rangefinder needs to move. You will find it easier to take snapshots if you don't turn the ring the wrong way first and then have to turn it back again.

Another point which makes the 135mm lens a good focal length for snapshots is the fact that you can remain far enough away from the subject not to be noticed, yet the angle of view is not so narrow that it makes it difficult to frame the subject quickly.

Apart from snapshots, this focal length is suitable for sport and wildlife photography, landscape and portrait photography and also, of course, for photographing details. At the minimum focusing distances of 1.5m, a subject area of 22x33cm will fill the format of a 35mm slide using the two slower lenses, and the MD 135mm,f/2 will even cover an area of 18x27cm - at a distance of 1.3m.

The Long Telephoto : A Bridge to the Subject

Minolta offer five lenses which constitute the group of true telephoto lenses; the MD 200mm,f/2.8, the MD 200mm,f/4*, the MD 300mm,f/4.5, the MD 300mm,f/5.6* and the RF 250mm,f/5.6*, which is an outsider within this group not only in terms of its focal length.

The difference in speed between the two 200mm lenses only amounts to one stop, yet the difference in price is considerable, and the difference in weight of almost 300g is not to be ignored, particularly if you have to walk far!

The difference in speed of only around two-thirds of a stop between the two 300mm lenses is not too serious but the difference in price is much less.

Whereas, of the two 200mm lenses, I definitely tend to favour the 200mm,f/4, even if this occasionally involves loading the camera with a faster film (unless you are going to make a point of frequently taking pictures of indoor sporting events), I would recommend the faster of the two 300mm lenses. Not because of the faster speed - although this plays a different role with these two lenses than with the 200mm lenses. The small maximum aperture of f/5.6 can lead to one half of the split image rangefinder going dark, which makes focusing difficult. This danger exists even at f/4.5, but under normal conditions, the split image rangefinder is an effective aid to focusing.

There is another thing which makes me tend to prefer the MD 300mm,f/4.5. It features internal focusing. This means that the lens does not - as is usually the case - become longer when one focuses on a close object. Only elements inside the lens move when the focusing distance is being set. The constant length keeps the lens better balanced and makes it easier to handle, and this is an important point with the longer focal lengths if you are concerned with producing technically perfect pictures.

200mm and 300mm lenses are often described as being

ideal for sport and wildlife photography, yet that is not quite true, even if it is not entirely wrong.

In open game reserves you are obliged to approach the animals very closely in order to achieve format-filling shots with a 200mm lens, and even an additional 100mm of focal length does not always necessarily guarantee a photographic bull's-eye. Nor can you achieve much with a 200mm lens when taking sports pictures - particularly if you, as a spectator, have to take your pictures from the stands of a large stadium and cannot get as close to the action as the professional photographers. On the other hand, these focal lengths are ideal for smaller events where you can get close to what's happening.

Of course, I am not trying to talk you out of getting a 200mm or 300mm lens - good wildlife shots can certainly be obtained using the 300mm lens - but I don't want you to expect too much and then be disappointed.

When, then, are 200mm and 300mm lenses to be recommended? When taking pictures of children, for instance. You can remain at a distance and yet still achieve pictures in which your son or daughter fills the whole frame without having half the play-ground in the shot, distracting the viewer from the real subject. Keeping at this distance from the subject means that the children remain concentrated on whatever they are playing at, allowing you to photograph them as they are, rather than as they behave when they see they are being photo-graphed.

The lenses with focal lengths of 200mm and 300mm are also ideal for those who like to photograph details. With this sort of shot in particular, the narrow angle of view restricts the distracting background considerably and the very shallow depth of field allows you to put this remaining bit of background out of focus. So, using these lenses, it is quite possible to take pictures of flowers which stand out colourfully against a washed-out, blurred background.

The long focal lengths also have their place in the field of landscape photography. They allow you to photograph

the single tree in the middle of a field of corn, they bring the mountain peaks closer and, through their narrower angle of view, they eliminate from the picture the concrete block of a hotel which disfigures the view of the alpine lake.

In addition, the compressed perspective of the tele-photo lens comes into full effect with these lenses. Chains of hills which are, in reality, separated by miles, appear almost to grow into one another in the picture. Despite this effect of compression, landscape shots taken with a tele-photo lens convey a good sense of depth. The air is unfortunately not pure, and the more air there is between the lens and subject, the more pollution is also shown in the picture. Each speck of dust may be invisible to us but the mass of dust particles takes away some of the picture's clarity (you shouldn't blame the lens for this). The more distant a part of the subject is, the more blurred it appears, which introduces an element of depth into the two-dimensional picture. In addition, distance makes things appear more blue. More and more colours are filtered out of the subject, until only blue remains for the most distant line of hills.

I have spoken of 200mm and 300mm, but I haven't forgotten the RF 250mm, f/5.6. It is distinguished from the other four lenses by its construction. It is a mirror reflex lens, a lens in which lens elements and mirrors work together to produce an image.

The mirrors are used to fold up the path of the rays of light. The light passes through the ring-shaped front element (which is how you can recognize a mirror reflex lens) of the lens onto a mirror, also ring-shaped, at the back of the lens. From there, it is reflected back onto a disc-shaped mirror which sits in the middle of the front element, and is passed from there onto the film. This technique means that the physical length of the lens is much shorter than that of a normal telephoto lens of the same focal length.

The second advantage of mirror reflex lenses is their

lightness, but this is associated with one serious drawback: Mirror reflex lenses have to get by without an adjustable aperture. If the light is too bright for the combination of the film speed, the only aperture setting of the lens and the fastest shutter speed of $^1/_{1000}$ sec, then you can, it's true, use a neutral density filter to block out some of the light but you will not gain any extra depth of field, which is, in any case, not particularly spectacular at a focal length of 250mm. Nevertheless, the RF 250mm,f/5.6 reflex lens is an interesting alternative to the 200mm and 300mm lenses in the Minolta range. It can be used for the same range of subjects as the normal telephoto lenses.

Incidentally, a picture taken with a reflex lens can often be identified immediately. The circles of confusion which appear when normal lenses are used become rings of confusion. These rings, however, are not only immediately apparent in the picture, they are also visible in the viewfinder. This makes focusing easier, which is very important, since you are always working at maximum aperture and therefore minimum depth of field.

The Super-Telephoto Lenses

I shall deal very quickly with the next group of lenses with fixed focal lengths of 400mm and longer. Weighing upwards of 1.5kg and costing a thousand pounds or more, these lenses are beyond good and evil as regards the field of amateur photography. Nevertheless, they are not simply prestige objects which are only included in the range in order to show what Minolta is capable of.

Sports photographers could hardly get by without focal lengths of 400mm and more, and anyone specializing in wildlife photography will also be obliged to dig deep into their pockets and then carry some heavy gear around. And - it must also be said - these giant lenses are not merely

fascinating from a technical viewpoint, they are also impressive in creative terms. A sunset which appears banal and boring when taken with a standard lens because you have already seen dozens of them, becomes a visual experience when taken using the RF 800mm,f/8*. The blood-red ball of the sun hovers above the horizon with a diameter of 8mm (basic rule: The sun and moon are reproduced on the slide or negative with a diameter of roughly $^1/_{100}$ of the focal length of the lens used) - so in horizontal format, it takes up one third of the height of the picture and looks impressive because of its sheer size. If the foreground also forms an interesting composition, you can't really go far wrong. Shots of animals taken with a 400mm or 600mm lens are also fascinating, because you rarely get a chance to look a lion in the eyes at this close range.

But not all that glisters is gold. The depth of field decreases rapidly with increasing focal length, and if you try out the lens at its shortest possible range you will find yourself confronted with problems which were never considered when dreaming of a super-telephoto lens.

The focusing distance must be set very precisely because the depth of field is insufficient to cover focusing errors; the infinity point varies according to the temperature so it is not possible to simply turn the focusing ring to its end position and assume that everything which is infinitely distant will be in sharp focus; even the bright viewfinder of the X-300s seems dark when the lens has a maximum aperture of f/6.3 or f/8 or even f/11. And, as when using high-magnification binoculars, it is by no means always easy to locate the subject straight away when the angle of view is so small and you can see just how much your hands really shake. And finally, notice how little light illuminates the scene, because the fast shutter speeds required often require a wider aperture than the lens can offer.

In addition, because these lenses are often used to photograph subjects which are very distant, there is a lot

Minolta MD-Apo 400mm,f/5.6*

of dirty air shimmering between the lens and the subject. And this has a negative effect on the picture, which seems unsharp and dull.

This last group of five lenses includes the two apochromatically-corrected lenses MD-APO 400mm,f/5.6* and MD-APO 600mm,f/6.3*. (particularly with lenses of long focal lengths, chromatic aberration causes fringes of colour to run along the edges of the subject because the three colour components of white light - red, green and blue - are not focused on the same plane). The other three are the RF 500mm,f/8, RF 800mm,f/8* and the RF 1600mm,f/11*.

As the front elements of the super-telephoto lenses are too large for normal screw-in filters to be used, the filters are placed within the lens or behind the last element. The exterior of the 800mm and 1600mm lenses are painted in light colours to prevent them from being affected by strong sunlight and expanding, which would have an adverse effect on the picture quality.

Minolta MD-Apo 600 mm,f/6.3*

101

The Specialists - For Difficult Situations

The range of lenses with fixed focal lengths also includes nine special models which are optimally designed for very specialized areas of use, but which can also, to some extent, be used for perfectly normal photography.

The Close-up Specialists

Six of the nine specialist lenses in the Minolta range of lenses are designed for use in the macro range, which covers reproduction ratios which provide tenfold reduction (1:10) to tenfold magnification (10:1). Only two of the six are normal lenses like all the others we have looked at, which can be focused to a particular distance by adjusting the focusing ring.

These are the MD-Macro 50mm,f/3.5 and MD-Macro 100mm,f/4, which can also be used quite normally in accordance with their focal length. However, apart from their optical structure, they also differ mechanically from other 50mm or 100mm lenses. They are fitted with an extra-long helical thread which allows a very long lens-to-film distance and thus a very short focusing distance. This, in turn, produces maximum reproduction ratios of 1:2, which means that the subject field is only twice the size of the film format. Pictures with a reproduction ratio of up to 1:1 are made possible by the use of a 1:1 adapter, which directly extends the lens-to-film distance even further.

As the front element of the 50mm macro lens is recessed very far back, one can dispense with a lens hood, which is essential for all other lenses; a special lens hood is available for the 100mm macro.

The first time that you work with this sort of lens, you will certainly be fascinated by the new world which you discover, but you will also be confronted by new problems. The maximum apertures, which are not very wide to begin with, are further decreased with increasing lens-to-film distance; camera shake is also magnified with greater

Minolta MD-Macro
100 mm, f/4

Minolta Auto-Bellows-Macro 50mm, f/3.5 Minolta Auto-Bellows-Macro 100mm, f/4

reproduction ratios. That means that very fast shutter speeds are not possible - yet at the same time they are necessary. Only in exceptional cases is it worth changing to faster film because, normally, you want to show the finest structures in the picture, and you don't want these to be affected by the graininess of the film.

So in many cases, macro photography means working with a tripod or artificial lighting. There is even a special flash unit available for this purpose.

You can, of course, use other means of assistance. A mirror is often sufficient to shed enough light on the subject, not to the extent that the tripod becomes dispensible, but at least so that you can stop down, which is very important with macro photography. The depth of field becomes minimal within this range; even the 50mm, at a reproduction ratio of 1:1, has no advantage over the 100mm lens with its longer focal length. Within the macro range, the depth of field is principally determined by the reproduction ratio.

The 100mm lens does have one advantage over the 50mm lens. The longer focal length means that it is not necessary to get so close to the subject as with the shorter focal length lens. This is an advantage which should not be underestimated, particularly if you intend to use small animals as photographic models. If you get so close to the animals that you scare them away, the shot is lost anyway.

The Auto-Bellows Macro 50mm,f/3.5 and Auto-Bellows Macro 100mm,f/4 lens heads also have the same optical structure as the two macro lenses; they also have corresponding focal lengths and speeds. The difference lies in their mechanical structure. These lens heads do not feature a helical sleeve thread. So they cannot be focused without additional help. This is provided by one of the bellows units, and as the lens head is fitted with an automatic aperture, it is worth buying the automatic bellows unit which allows you to make use of this function.

With a bellows unit, the 100mm lens head can even be used as a normal lens, as it can be focused from infinity up to a reproduction ratio of 1.3:1 (slight magnification). The 50mm head does not share this advantage; its focusing range covers the reproduction ratios 1:1.25 to 3.2:1, i.e. from slight reduction to over three times magnification.

The third pair of lenses designed for close-up work are the Bellows-Micro 25mm,f/2.5* and the Bellows-Micro 12.5mm,f/2. The lens head with the longer focal length allows reproduction ratios of from 3.2:1 to 9.3:1 and almost ten times magnification - which is quite something! It is

even easier to turn an ant into an elephant if you use the 12.5mm micro. The reproduction ratios here range from 8:1 to 20.5:1.

These two lens heads can only be used together with a bellows unit, but the simpler bellows model can be used in this case. The micro lens heads have preset apertures.

Minolta Bellows-Micro
12.5mm,f/2*

Minolota Bellows-Micro
25mm,f/2.5

You set the focus at maximum aperture, stop down to the correct aperture and then make the exposure. The automatic shutter speed selection still functions, but in some situations the slowest shutter speed of 4 sec may not be quite sufficient. However, this doesn't mean that you will have to give up on the shot. Simply find out the aperture at which the LED next to 1 sec lights up. Now you can work out which shutter speed you need for your aperture setting. If it is three stops below the aperture setting which would be correct at a shutter speed of 1 sec, then the correct shutter speed would be 8 sec; if stopped down by a further stop, you would have to expose the shot for 16 sec. In this case, you set the shutter speed dial to "B" and activate the shutter with a cable release or via the self-timer in order to avoid camera shake.

The macro and micro lens heads can also be used with extension rings, but this is not really worthwhile because of the limited reproduction ratios.

The Specialist for Soft Pictures

You may be familiar with the soft-effect pictures made world-famous by David Hamilton. These pictures are diffused, and this can be achieved by using very simple yet effective methods. For instance, if it's cold enough, it's sufficient to breathe on the front element of the lens and - with your eye to the viewfinder - to wait until the misting has cleared to the stage where the desired effect is created. At warmer times of the year, it is better to smear a light neutral density filter, UV filter or skylight filter (see the filter section in the chapter on accessories) with vaseline in order to achieve a similar effect. Some photographers also make use of a piece of nylon stocking (best colour, very pale grey) stretched tightly across the front of the lens.

There is, however, a problem associated with these methods. The effect is not exactly predictable and cannot be controlled in smooth stages. That is only possible with the Varisoft 85mm,f/2.8 which puts an otherwise undesirable reproduction defect, spherical aberration, at the serv-

Minolta Varisoft 85 mm,f/2.8*

ice of the photographer. The reproduction defect creates an unsharp image which overlays a sharp picture, thus diffusing it. The effect can be smoothly controlled from 0 to 3 - at 0 the Varisoft is a perfectly normal portrait lens; at 3 a very strong diffuser. The aperture setting must be

planned into the diffusion effect, as it influences not only the depth of field but the degree of softness. If you have an X-700, the preview button will allow you to judge precisely what effect the aperture is having.

As the aperture setting plays an important role with this lens, only aperture priority or manual exposure control should be used. The program mode of the X-700 will not provide sufficient control, and should not be used with this lens.

The Specialist for Straight Lines

We have already encountered foreshortening in the chapter on perspective.

In order to avoid this, I recommended finding a higher camera position, perhaps the stairwell of the building opposite, in the case of a building. You might, though not in every case, be able to save yourself the walk if you have the Shift-CA 35mm,f/2.8 lens among your equipment. What happens if you make your way up the stairs to the second floor and take your picture from there? The optical axis remains in perpendicular alignment to the vertical lines of the building; it is seen from in front rather than from below, and the vertical lines have no reason to lean towards one another.

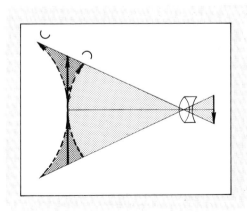

VFC function: On Minolta MD-VFC 24mm,f/2.8 and Minolta Shift-CA 35mm,f/2.8

107

Minolta Shift-CA 35mm,f/2.8*

The same principle is followed by the shift lens, the front part of which can be moved up, down, right or left in relation to the rear part, whereby it is possible to combine vertical and horizontal displacement.

The shift's vertical displacement brings more of the upper part of the subject into the picture while cutting off a certain amount at the bottom - yet it remains horizontal, so there are no converging verticals. In the case of very high buildings, the normally horizontal displacement can be converted to vertical displacement by taking the picture in vertical format. It may still be necessary to tilt the camera a little, but by no means as far as would be necessary without the displacement. And in the case of very high buildings, it is even a good idea to keep slightly converging verticals in the picture. The eye is accustomed to the fact that parallel lines seem to converge in the distance. If the vertical lines of an extremely high building are corrected until they are completely vertical, we see a building which seems wider at the top than at the bottom.

The possibility of horizontal displacement also has its advantages when taking pictures in horizontal format. You can virtually photograph around an obstacle by shifting it to the right or left of the picture.

As two sections of the lens have to be displaced in opposite directions, it is neither possible to control the

aperture from the camera nor carry out open-aperture metering. With the X-700, metering is carried out by pressing the depth of field preview button. Since this is not available on the X-300s, it is not possible to check the meter reading before making the exposure when using this camera.

So you just have to go ahead and hope for the best. You focus on the subject and set a small aperture, which may necessitate a slow shutter speed. The shift lens should be used from a tripod in any case if you want to make the most of the displacement. You then release the shutter, and in the moment between the closing of the aperture and the start of the shutter operation, the exposure is metered. A greater displacement can sometimes lead to false readings, which is why the manual supplied with this lens recommends a "slight" increase (about half a stop) depending on the degree of shift. If you take a lot of photographs of architecture and have to use the shift lens frequently, it is worth getting a separate exposure meter and setting the readings manually.

In addition to the displacement of the optical axis, the Shift-CA 35mm,f/2.8 offers another feature. The picture field can be curved out using an additional ring. The effect which this can have on a picture will be explained in connection with another Minolta specialist lens so that I don't have to repeat myself.

When so much effort has been put into a lens, it is not surprising that it costs so much. Although it is by no means the most expensive in the range, it is certainly up there with the top of the range.You may remember from the chapter on depth of field that I spoke of a "plane of critical focus". The Shift-CA 35mm,f/2.8 lens and the MD-VFC 24mm,f/2.8* make it possible to bend this plane, either towards the camera or away from it. What is the advantage of this feature? You will find that out when you have a widely spread-out subject before you but are obliged to use the maximum aperture setting, resulting in an insufficient depth of field. In this case, you can bend the depth of field

in such a way that it includes both close objects at the edge of the picture and distant objects in the centre of the picture or vice versa. Not all subjects are suitable for this sort of adapted focusing, but much can be photographed in sharp focus using this subject field curvature which would otherwise be unsharp.

The Zoom Lenses

The advantages of zoom lenses over lenses with fixed focal lengths have already been explained in an earlier chapter. The zoom lenses offered by Minolta extend from 24mm to 500mm and cover this whole range from virtually extreme wide-angle to super-telephoto without a gap. As no new focal lengths have been invented for zooms. I won't bother saying anything about individual lenses - you can check up on the pros and cons and areas of use under the sections on the relevant fixed focal length lenses.

If you decide to equip yourself with two or more zoom lenses, you should make a point of choosing only one-

touch zooms or only two-touch zooms, if this is possible. Like the rest of us, you are probably a creature of habit, and if you have been working with one-touch zoom A for a while, it can easily happen that, after changing to two-touch zoom B, you turn the focusing ring without achieving any change in the focal length. If possible, you should also try and use one-touch zooms which have the same orientation (longest focal length at front or rear end positions). This advice may sound rather cautious, but once you have messed up three snapshots on holiday because, in your haste you have turned the ring in the wrong direction, you will see my point.

The Wide-Angle Zooms - Correctly-framed Overall Views

Of the six zooms belonging to this group, the four with the shorter range of focal lengths are two-touch zooms - which is not necessarily a bad thing. As a rule, wide-angles are used to photograph stationary subjects, architecture, landscapes, and group portraits. This gives you enough time to set the focal length exactly on the extra ring once you have focused at the longest focal length.

The MD 24-35mm,f/3.5 is a pure wide-angle zoom which can be regarded as an ideal substitute for the 24mm and 35mm lenses. The next zoom, the MD 24-50mm,f/4*, also replaces the 50mm lens and is therefore your best choice if you intend to explore the lower range of focal lengths. This has to be balanced against the price, which is not exactly cheap - at least at first glance. The expense naturally becomes relative if you consider what a 24mm, a 28mm, a 35mm and a 50mm lens would cost together, bearing in mind that all the focal lengths in between are also available.

Both zooms are distinguished by a constant initial

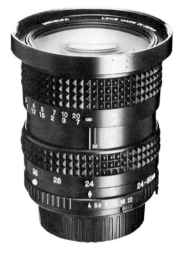

Minolta MD-Zoom 24-50mm,f/4* Minolta MD-Zoom 24-35mm,f/3.5

aperture over the entire range of focal lengths, as is the 35-70mm,f/3.5, which is still regarded by many as the best standard lens around, whereas others would award this title to a lens such as the MD 28-85mm,f/3.5-4.5 or the newly-introduced 28-70mm,f/3.5-4.8.

Above all, this lens is a complete set of equipment in itself, because 28mm to 50mm covers the part of the wide-angle range in which most subjects are to be found while 85mm is already sufficiently long-focus for many purposes. The 35-70mm zoom, on the other hand, is a standard lens - albeit a considerably expanded one - which could be supplemented with a long-focus zoom and perhaps a fixed focal length lens with a significantly wider angle of view (24mm, 20mm).

The 28-85mm lens is the first zoom we have come across which features a variable maximum aperture. When zooming, the positioning of lenses, lens groups and aperture relative to one another is varied, which results, on the one hand, in a change of focal length and, on the other hand, in a change in the size of the entrance pupil. If the

112

Above: *Whether real or staged - this snapshot shows that the important thing is to have an eye for a good picture. (Gunter Hankammer)*
Below: *A shot taken from above adds variety to a sequence of pictures - particularly when the subject, with its repetition of groups of three, has already been well studied. (Rainer Plozer)*

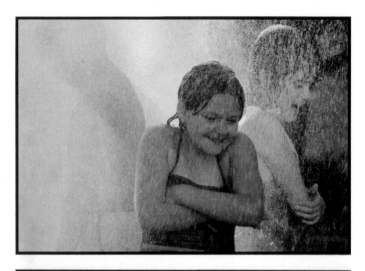

Above: *It is important, when taking snapshots, for the photographer to stay in the background - the subject should not have the opportunity to "present themselves" to the camera. (Ray Vaughn)*
Below: *The distant camera position makes the most of the fog and the willow trees - very important for the melancholic atmosphere. (Luigi Degan)*

Minolta MD-Zoom 35-70mm,f/3.5*

Minolta MD-Zoom 25-105mm,f/3.5-4.5

change in size is proportional to the change in focal length i.e. if the opening becomes larger in proportion to the increasing focal length, then the relationship between focal length and entrance pupil remains constant and so, consequently, does the speed of the lens. If the diameter is not altered in the same proportion as the focal length, the result is a variable lens speed and consequently a variable aperture opening. This doesn't affect the TTL metering, as the light which falls onto the metering cell in the viewfinder prism is measured. When taking flash shots with manual setting on the camera based on flash guide numbers, or with the flashgun in computer mode, it is a good idea to set the aperture accordingly for extreme focal lengths and select the intermediate value for focal lengths in between, as long as it is possible to set the aperture in half stops. With the X-700's Direct Autoflash Metering, even this adjustment is unnecessary.

The MD 35-105mm,f/3.5-4.5 is, like the 28-85mm, an all-round zoom which is sufficient on its own for many photographic expeditions. Its range of adjustment is simply somewhat biased towards the long-focus end of the scale.

The MD 35-135mm,f/3.5-4.5 occupies a similar position, with the long-focus area even more strongly emphasized.

All four zooms which have a shortest focal length of 28mm or 35mm are equipped with a so-called macro setting, thus allowing a maximum reproduction ratio of 1:4, which means that the subject is reproduced on the 35mm film at a quarter of its actual size. The shortest focusing ranges lie between 25cm (28-85mm) and 45cm (35-135mm).

These macro settings are no substitute for a true macro lens as regards the reproduction ratio achieved or in terms of quality. Not that the macro setting isn't worth using. It is quite adequate for certain close-up snapshots. This is particularly true if the subject is a flower or butterfly and you can get close enough, because in both cases the actual subject will be in the centre of the picture. Whether or not the surrounding areas are reproduced with perfect sharpness doesn't matter, considering that the centre and borders of a slide mounted without glass are hardly ever projected in sharp focus at the same time. But as soon as you try to photograph something flat - an intricate jigsaw or an old map which you want to photograph in order to liven up a slide show - you will have to resort to stopping down in order to achieve worthwhile pictures. But that should not be taken as a vote against the macro setting. It is quickly accessible without having to buy and carry around another lens, and anyone seeking perfection in their close-up shots can always choose from two lenses and four lens heads plus bellows unit.

The two zooms which reach to 105mm and 135mm focal length are one-touch zooms, which is good. These lenses are used for snapshots, quick pictures at sporting

116

events, and it is advantageous here if focus and focal length can be set with one hand movement - though this requires a certain amount of training and a few hours of practice.

The Telephoto Zooms - Made-to-Measure Details

If a 35-135mm lens is regarded as being one of the wide-angle zooms, because the shortest focal length falls into the wide-angle category, then a 50-135mm zoom would logically have to be described as being a standard lens. But as we don't want to exaggerate, we can include the MD 50-135mm,f/3.5 with the telephoto zooms, a group which contains six lenses.

Isn't 50-135mm a poorly-chosen range of focal lengths considering that a 35-135mm lens is already available? Certainly not. If you are not interested in wide-angle shots, you don't need the superfluous focal lengths, and if you already have a 35mm lens - and find it adequate - you don't need the wider range of focal lengths either.

Minolta MD-Zoom 75-150mm,f/4*

Minolta MD-Zoom 70-210mm,f/4

The same question applies to the MD 75-150mm,f/4*, as there is an MD 70-210mm,f/4 which is just as fast. But here again, the shorter zoom is not superfluous, because anyone who already owns a lens with a fixed focal length of 200mm or 300mm will not want the 70-210mm lens. You must bear in mind that the 70-150mm has one advantage over the 70-210mm lens; it is almost 200g lighter, a weight which hikers would take into consideration when planning their equipment for a long trek over mountainous terrain. On the other hand, of course, the 70-210mm zoom can claim the greater range of focal lengths up to long telephoto and the greater maximum reproduction ratio of 1:3.9, instead of 1:6.3 in the case of the 75-150mm.

The MD 100-200mm,f/5.6* could also be classed as the third lens in this group. Its range of adjustment also only extends to doubling the focal length, like the 75-150mm

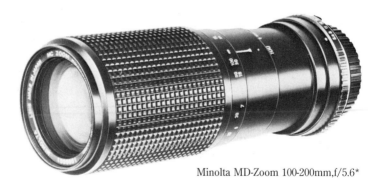

Minolta MD-Zoom 100-200mm,f/5.6*

lens, but at 200mm it reaches the long telephoto range; it is heavier than the 75-150mm, but no lighter and no smaller than the 70-210mm lens, and its greatest reproduction ratio is, at 1:10, not exactly impressive, any more than its speed of f/5.6. Even if the individual disadvantages weren't so bad in themselves, this combination makes it compare unfavourably to the 70-210 zoom which isn't even any dearer. Nevertheless, if you have bought the 35-105mm as your first zoom lens, then this 100-200mm lens will serve you well as long as you are not thinking of longer focal lengths.

If, on the other hand, you want a zoom which will take you into the realm of extreme long-focus lenses, you might consider the MD 100-300mm,f/5.6 lens. It is only marginally heavier than the 70-210mm and has the same diameter, but is over 3cm longer. You will, of course find this zoom more useful for sport and wildlife photography than the fixed focal length 300mm,f/5.6, which is only 5g lighter, 1mm shorter and 8mm narrower. The fixed focal length lens also only has a slight advantage in terms of price.

Even if a focal length of 300mm is too short, you can still turn to Minolta. They offer an MD-Apo 100-500mm,f/8* which, however, lies way above the other zooms in price; one thousand pounds wouldn't be enough to buy this huge (over 33cm) and heavy (over 2kg) lens. But not only is the price a deterrent. Working with this giant lens at maximum focal length without a tripod is not actually impossible, but is not to be recommended, and if a tripod is used, you lose the single-sleeve zoom's big advantage of speed unless you have had a lot of practice. Nevertheless, the 100-500mm is a fascinating lens, as the apochromatic correction allows you to achieve a very high quality of picture - which should not be taken for granted with this sort of focal length.

A special achromatic supplementary lens is available, which extends the close-up range - up to a maximum reproduction ratio of 1:2.2.

Tele-converters - The Other Option

Tele-converters have the convenient characteristic of being able to extend the focal length of a lens - doubling it in the case of the 2x tele-converter. A 24mm becomes a 48mm lens, and you can already see from this example that wide-angle lenses are not the best partners for these converters. Those are the telephoto lenses - a 100mm lens becomes a 200mm lens, a focal length of 200mm is stretched to 400mm, and a 300mm lens becomes a 600mm lens, and therefore a genuine extreme telephoto lens.

Tele-converters are small optical systems with lens elements which must be just as precisely ground and fitted into their mount as with a normal lens, and they must be precisely matched to the lens with which they are to be used. All this is by no means simple, and good tele-converters therefore cost a lot of money. Seen from this viewpoint, the tele-converter is not the right partner for a 100mm lens, because the 200mm,f/4 is quite a lot cheaper than the tele-converter.

With a 200mm lens, on the other hand, which becomes a 400mm lens, it is quite worthwhile, and even more so with a 300mm lens which turns into a 600mm lens.

Another point in favour of tele-converters is that they are small. They can be kept in the camera bag and are always at hand when maximum focal lengths are required. In such cases, the 400mm and 600mm lenses, if you've been able to afford them, would probably be lying in the cupboard at home.

One further advantage of the tele-converters. They not only double the focal length, at the same time they also happen to double the maximum reproduction ratio because the shortest focusing distance remains the same.

There is, of course, a disadvantage. All aperture settings are reduced by two stops when you use a 2x tele-converter. The MD 100mm,f/2.5 becomes the MD 200mm,f/5, the MD 200mm,f/4 becomes the MD 400mm,f/8, and when you set the aperture ring to f/8, you get f/16.

Of course, you can still rely on the automatic exposure metering of the X-300s or X-700 despite this, but you should keep an eye on the shutter speed scale to check that you are still within the camera shake-free range.

There remains the big question. What about quality? Earlier generations of converters were not particularly impressive in this respect, and many amateur photographers still remember the results with horror. The modern converters have, of course, also benefitted from the development of lens technology. Even though they are still a compromise between convenience and perfect quality, you will only very rarely be able to tell from a picture whether a converter was used or not, as long as it was possible to stop the aperture down.

This group includes the two Minolta focal length extenders, the MD 2x Tele-Converter 300-S and the equally heavy, but somewhat thicker, MD 2x Tele-Converter 300-L, each lens having different fields of application.

In general, one can say that the 300-S is the all-round converter which can be used with all lenses, including zooms, up to a maximum focal length of 300mm, producing good results. Only the shift lens resists being used with the converter, but that wouldn't be very practicable in any case.

Minolta MD 2 x Tele-Converter 300-S Minolta MD 2 x Tele-Converter 300-L

The 300-L, on the other hand, should be reserved for use with lenses with fixed focal lengths of 200mm and above, when it produces its best results (with the exception of the RF 250mm,f/5.6). It should on no account be used with the fisheyes, the extreme wide-angle lenses including the VFC 24mm,f/2.8, and the Shift-CA 2.8/35mm, the standard lenses of around 50mm (you may still have a 58mm,f/1.2 from an old SR-T 303), including the 50mm macro, nor should it be used with the 24-35mm, 24-50mm, 35-70mm, 28-85mm or 80-200mm lenses. If you wish to avoid damaging the converter or the lens, you should use the 300-S with all of these lenses.

Both converters - as you will have guessed by the name - are MD lenses, which means that they can be used with open-aperture metering and automatic exposure metering, in all models including the X-700's program mode.

Lens Combinations

Only having one lens for an SLR camera means missing out on many of the opportunities offered by a camera system of this sort. Of course the acquisition of a lens is also a financial question - sooner or later you've saved up the money and another question arises. Which lens best supplements the existing one(s)? I would like to propose a few combinations of lenses which turns your X-700 or X-300s into a photographic system capable of dealing with all areas of use.

24mm to 200mm with Fixed Focal Lengths
The MD 24mm,f/2.8 has the shortest focal length, and the wide-angle range is further covered by one of the 35mm lenses. If you take a lot of pictures at twilight, you can fill the gap between these and the MD-Macro 100mm,f/4 with a fast 50mm lens; perhaps you still have the original

standard lens which came with the camera. The long-focus range is completed by the MD 200mm,f/4, or, for available-light specialists, the MD 200mm,f/2.8. Shots requiring a longer focal length can be taken if you carry the 300-S converter with you, giving you a 400mm lens with a speed of f/8 or even f/5.6!

17mm to 300mm with Fixed Focal Lengths

The two extremes are represented by the MD 17mm,f/4 and the MD 300mm,f/5.6, which can be turned into a 600mm lens using the 300-S converter if required. The 300-S should be used because this converter is better suited to the MD 135mm,f/2, which covers the medium telephoto range. The range is completed by a 35mm lens and the 50mm macro lens.

Bridging the gaps between focal lengths using only lenses with fixed focal lengths may be a good idea as regards achieving maximum quality, but sooner or later you will miss the opportunity offered by a zoom lens for framing a shot perfectly.

17mm to 300mm with Zooms and Fixed Focal Lengths

The centre-piece of the trio is the 28-70mm or 28mm-85mm two-touch zoom which you supplement with the 17mm lens for wide-angle use, and with the 200mm lens for tele use. Of course, the 20mm can also be chosen as an extreme wide-angle lens, but that is really a matter of personal preference.

35mm to 200mm with Zooms

Variant 1: The MD 35-70mm,f/3.5 two-touch zoom and the MD 70-210mm,f/4 one-touch zoom, which might lead to problems when having to switch from turning the ring to sliding it.

Variant 2: You combine the two one-touch zooms, MD 35-105mm,f/3.5 and MD 100-200mm,f/5.6, which prevents any confusion when quickly changing lenses. In

addition, both lenses are constructed in the same way, i.e. the shortest focal length is achieved by pulling the focusing barrel towards you. If you have ambitions in the macro field, you can supplement this interesting combination with the 50mm or 100mm macro lens, or, if you take a lot of architectural pictures, you can add the shift lens to the two zooms.

In a further variation on this two zoom outfit, the 100-200mm lens is replaced by the 100-300mm lens, which extends the zoom range even further without making the equipment much heavier or more expensive.

I personally tend to favour variation number three, which has two advantages. The 35-105mm zoom can be used better on its own than the 35-70mm, and the range of focal lengths is considerably larger. The 300-L converter can provide you with an 100-600mm,f/11 zoom, though you would need a good tripod. In order to achieve worthwhile pictures the zoom/converter combination needs to be stopped down by one to two stops.

Where two zooms form a complete outfit, it is worth considering keeping each of the two lenses on its own camera body. This means that you don't have to bother about changing lenses, which still takes up time, even if the bayonet fitting makes it fairly quick and easy. A second body is also useful in other respects. This gives you extra security when on holiday. You can never be sure that someone won't steal your camera and accidents can always happen. You don't need to drop your camera from the top of the leaning tower of Pisa - a perfectly normal grain of sand on Brighton beach can cause quite enough damage.

Using two bodies, you can also work with two different films at the same time; a fast ISO 1000 film for the evenings, and a ISO 100 film for daytime, for example. If, having bought your X-700 or X-300s, you are considering getting rid of your old Minolta - think twice about it! Or you could get yourself another body of the same type, which

has the advantage that you don't have to rethink every-thing when changing cameras.

24mm to 300mm with Zooms

The final series of focal lengths consists of three zooms, which unfortunately involves combining a two-touch zoom, MD 24-35mm,f/4, with two one-touch zooms, MD 35-135mm,f/3.5-4.5 and MD 100-300mm,f/5.6. The 100-300mm has the 300mm setting at the position nearest the camera but on the 35-135mm the 135mm setting is at the fully extended position. Using this outfit, you should be able to deal with any subject which comes in front of your camera.

If you are interested in close-up shots, you can supple-ment this outfit with an auxiliary close-up lens, the Achro-mat No.0; this allows you to take pictures with a maximum reproduction ratio of almost 1:2 using the 100-300mm zoom, without having to carry around a separate macro lens.

Another advantage of this outfit is that the 35-135mm zoom makes an excellent solo lens, and your X-700 or X-300s together with this one lens will compare well with quite a number of other lenses.

The camera, plus one or more lenses, forms the basis of the photographic equipment which you carry around in your camera bag. I would advise you to buy a camera bag which is larger than you actually need to start with. Firstly, you may acquire more lenses later and, secondly, lenses aren't the only accessories available for your camera.

There are flash units, for example, which we will deal with in the next chapter.

Flash Units - Independent of the Sun

Once you have equipped yourself with all the lenses you need, you can start to consider the other accessories which Minolta offer to go with your camera; flashguns perhaps.

If we exclude the special macro flash - we will come to that later - Minolta offer two different series of flash units, one for the X-300s and the other for the X-700.

From the PX series:
● Auto-Electroflash 360 PX
● Auto-Electroflash 280 PX
● Auto-Electroflash 132 PX*

From the X series:
● Auto-Electroflash 220 X
● Auto-Electroflash 132 X
● Auto-Electroflash 118 X
* No longer in price list

The three units in the PX series are really designed for use with the Minolta X-700 and X-500. They can be fully integrated into the electronic system of these cameras and allow TTL automatic flash control. The 280 PX and the 132 PX therefore dispense with a sensor which measures the flash light reflected by the subject and switches off the flash once it has registered enough light. The other four do feature a sensor of this sort, and if you are buying a

flashgun for an X-300s, you should stick to one of these four or the Auto Electroflash 360 PX.

You needn't worry about the correct synchronization time with any of these flashguns - it is automatically set once the unit is ready to flash.

The synchronization speed of the X-700 and X-300s is $^1/_{60}$ sec. Why precisely that speed? After $^1/_{60}$ sec, the first shutter blind has already reached its destination, so the film is completely exposed before the second shutter blind is released. So the very brief burst of light from the flash can reach the whole surface of the film in this instant. If the first blind were still moving, the flash would cast a shadow of the blind onto the film, and one side of the picture would have a black bar down it. As the blind is drawn to the left, the left-hand side of the frame would be masked out, but since the image is projected back-to front and upside-down onto the film, it is the right-hand edge of the picture which would come out black. Slower shutter speeds can be used for synchronization, since the flash is triggered more or less simultaneously with the release of the shutter and, thanks to the brief duration of the flash, has already finished its work by the time the second blind is released, after $^1/_{30}$ or $^1/_{15}$ sec, in order to cover the film again.

The 360 PX is the most powerful of these units with a guide number of 36, followed by the 132 X/132 PX (GN32), 280 PX (GN 28), 220 X (GN 22), and the 118 X (GN18).

The guide numbers state the power of a flash at a specific film speed, related to the distance from the subject. In the case of Minolta flash units the film speed to which they refer is ISO 100. The guide numbers refer to distances in metres.

Flash photography using the guide number method is possible with all six of the units mentioned at the start of the chapter. For example, you are using the Electroflash 280 PX, which has a guide number of 28, and a ISO 100 film. Now you simply decide how far away your subject is. You can either read this off the focusing ring after setting the focus or, if you can judge distances by eye, you can

The Electroflash 220 X is a handy, compact unit with a good range of features. A guide number of 22 is adequate for normal indoor photography. The variable-angle reflector is particularly important, because indirect lighting is softer and therefore produces a better effect in the picture.

1 Reflector head
2 Flash reflector
3 Battery compartment cover
4 Sensor opening
5 Adjustment screw for mounting foot
6 Mounting foot
7 Synchronization contact

estimate it. Let's assume that the result is 7m. You divide the guide number 28 by 7 and come up with 4. That is the aperture which you must set on your camera in order to achieve a picture which is correctly lit by flash. Other guide numbers apply to different film speeds. It's very easy to work these out, because the guide numbers change according to the same principle as the f/numbers. The initial value must be multiplied by the square root of 2, which is approximately 1.4. The guide number for the 280 PX and an ISO 200 film would therefore be 28 x 1.4 = 39 (rounded off). If you multiply this guide number once more by 1.4, this will give you the guide number for ISO 400, but you get the same result if you multiply the original guide number by 2, as the square root of 2 x the square root of 2 is, after all, 2.

If you have paid close attention, you will see that you can use the guide numbers as a basis for calculation. There are five stops between ISO 100 and ISO 1600, and starting from f/1, four stops lead (via 1.4 - 2 - 2.8) to 4. So if you multiply the guide number at ISO 100 by 4, you get the guide number for ISO 1600, which in this case is 112.

But with the Minolta Auto Electroflash units, no such calculations are necessary. Flash exposure can safely be left to the computer which is built into the flashgun, or in the case of the X-700, into the camera itself.

The X-700 employs Minolta's Direct Autoflash Metering system, usually referred to as TTL flash. Instead of a

sensor in the flashgun, this system uses a metering cell inside the camera which reads the amount of light reaching the film surface. When the correct exposure has been achieved, the camera sends a signal to the flash unit, causing it to switch off. This method has a number of advantages, as it can be used with any aperture, and requires no exposure adjustment for filters, extension tubes, bellows or similar lens attachments. Any PX-series flashgun can be used with this system.

The X-300s does not have Direct Autoflash Metering, but you can still have automated flash exposure if you choose one of the X-series flash units, or the Auto Electroflash 360 PX. These units all have a sensor in the front panel, which controls the exposure and offers a choice of usable apertures.

The 360 PX offers you a choice of three apertures, the other units two apertures, which guarantees you flash pictures which are automatically correctly exposed. For ISO 100, these apertures are 2.8, 5.6 and 11 for the 360 PX; 4 and 8 for the 132 X; 2.8 and 5.6 for the 220 X; and for the 118 X, f/2 and f/4. The shortest distance at which a correctly exposed picture can be taken at one of these aperture settings is 70cm for all of these flash units, the maximum range is 13m (360 PX), 8m (132 X), 7.8m (220 X) and 9m (118 X).

When using flash, it is not just the distance lit by the flash which is important - the angle of view lit by the flash is equally important or, in other words, which focal lengths can still be used to take wide-angle shots without the edges of the picture being too dark. Without additional accessories, the lower limit for all these units is 35mm. You can only take pictures using a 28mm lens if you use the additional diffuser, which is supplied. For the 360 PX there is also a 24mm diffuser, but this is only available as part of the Panel Set, which also includes a selection of colour filters.

One problem with flash shots is without doubt the fact that the hard light from the flash casts harsh shadows,

The Power Grip 2 with its own shutter release button and power supply allows pictures to be taken at a faster rate with more effective use of flash.

another disadvantage is the flat lighting which is always associated with light falling directly onto the subject. The solution to this problem is indirect flash or bounce flash, as it is also known.

Indirect flash is most easily achieved with the 360 PX and the 132 X, the more powerful flash also being the more versatile. Its reflector can be tilted upwards (by 90°) and turned to the left or right (by 90°), whereas the 132 X can only be tilted upwards by 90°.

This allows the flash to be bounced onto the subject off the ceiling or a wall; in doing so, it is diffused, producing softer shadows and no longer striking the subject directly, therefore giving it more structure and strength.

If a ceiling or wall is used as a reflective surface, you should make sure that it is white. Any colour will also

colour the flash light slightly on its way to the subject, and the subject will suddenly take on a colour cast which you might find puzzling at first glance.

The angle at which the flash is tilted depends on the relative positions of the flashgun, the subject and the reflective surface.

As a result of the detour, the flash light travels a greater distance than if it is reflected directly from the subject onto the film. When using computer flash, whether TTL or sensor controlled, estimate this distance and make

The Motor Drive 1 is equipped with two shutter release buttons and a moulded handgrip for comfortable picture-taking in horizontal or vertical format.

sure that the maximum range is at least as great as the aperture selected will allow. When taking flash shots using guide numbers, simply base your calculations on the greater distance and this will give you the correct aperture setting.

But there is not always a ceiling or wall handy for bouncing the flash. For cases like this, Minolta offer a reflector umbrella made of white material which is fitted at an angle of 45° above the reflector, which is pointed straight upwards. The umbrella diverts the light towards the subject and makes it softer, which is particularly important if you want to take portrait shots using only a flashgun.

With the Minolta X-300s, "off-camera" flash is only possible with the 360 PX, with or without the Power Grip 2. If you have an X-700, a range of adaptor cables is available which enables you to use all the PX-series flashguns off-camera while retaining full automation. The 360 PX and 280 PX will allow you to take a rapid series of flash shots, using the Auto Winder G. If you are using the faster Motor Drive 1, you will also need the Power Grip 2 to achieve a rate of 3.5 frames per second with flash.

As good as the Minolta flash units are, they still produce a very cold, hard light. I would therefore advise you to avoid using a flashgun if at all possible if you want to reproduce a particular atmosphere in a picture. It's better to photograph stationary subjects from a tripod using a slower shutter speed. If the picture includes people who cannot stand still for long, use very high speed film.

Winder or Motor - Faster than the Thumb

When taking pictures with the X-300s, you transport the film forwards after taking the shot by winding the film advance lever forwards by 130º from its starting position. Nor is it possible to release the shutter until you have done this, because the shutter is only cocked when the film is transported. This linkage is very practical, since it prevents you, in the heat of the moment, from accidentally exposing six shots onto one frame of film. However, if you are determined to make a double exposure, you may curse this feature intended to prevent double exposure. It can, however, be overcome.

Take the first shot at half the exposure which the camera considers necessary, because the film will be exposed twice. Then press in the rewind release button on the underside of your camera and operate the film advance lever. This now only cocks the shutter, as you have uncoupled the transport mechanism. Keep the film tensioned during this procedure with the help of the rewind crank. The second exposure should also be made at half the correct exposure. Don't expect double exposures to turn out successfully every time. The film might have slipped a bit and if part of the subject is exposed twice, this can lead to ugly contours so it is a good idea to only make double exposures in the middle of a film in order to avoid this problem. However, be warned, making double exposures this way could cause excess wear to the winding gears over a period of time.

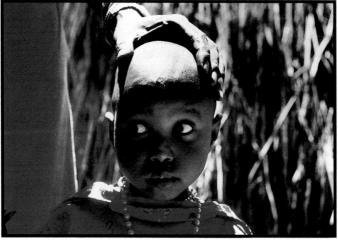

Above: *A simple composition and sparse colours were used to capture this contact between human and animal. The important feature is the division of the picture into two halves, which are, however, connected by the rope and the plants. (Ursula Degenhard)*
Below: *Pictures of children are often more successful if the child is distracted and, for a moment at least, forgets about the camera. (Dagmar Pfeiff)*

Above: *When taking animal portraits, patience is just as important as having the right equipment, which should include a fairly long-focus lens. (Helmut Hogerle)*
Below: *The stork requires an even longer focal length than the cat, because it is not used to being with people. (Roland Pfitzer)*

For some situations the film advance lever takes too long to transport the film. Minolta offers a remedy, the Auto Winder G and the Motor Drive 1.

Winder G is simply screwed into the tripod socket of the X-700 or X-300s and couples automatically with the camera's electronics. If the shutter speeds are fast enough, the film is transported immediately after the second shutter blind has covered the film.

The motor drive, which transports the film at a rate of three and a half frames per second, is faster (again, given shutter speeds which allow this). It is also screwed into the tripod socket, also couples automatically and includes a handgrip on the right-hand side, which makes the combination of camera plus motor drive very easy to handle. A shutter release button is fitted on the handgrip so that you don't have to contort your finger, and a main switch which allows you to preselect single shot mode (the film is transported after each picture, then stops), slow picture frequency (2 frames per sec) or rapid picture sequence (3.5 frames per sec).

As motor drives or winders started to spread into the area of amateur photography, they were described as "film-destroying machines". In the meantime, it has become clear that automatic film transport offers advantages to the photographer, and not just to the film manufacturer.

This starts with the fact that you can keep your eye to the viewfinder without altering the framing of the shot because you have to remove the camera slightly from your brow to advance the film. Even the slight force exerted in advancing the film moves the camera out of position (Incidentally, this also applies to tripod shots taken without a motor drive). Using a motor drive and a zoom, you can take a picture of the general view at the wide-angle setting and then take the detailed shot of the castle on the hill whilst retaining its exact position in the shot.

Another advantage is the fast second shot. It happens quite often that somebody flits through the picture just as you are releasing the shutter. If you now have to wind the film on by hand, the situation which inspired you to take the picture will have passed. With a motor drive, you wait until the intruder has completely disappeared, then you immediately take another shot even framed exactly the same.

The third advantage. You can shoot series of pictures - of a galloping horse, for instance. Both the winder and the motor drive are a bit slow for this, but if you want to capture the individual phases of the animal's movement, you can

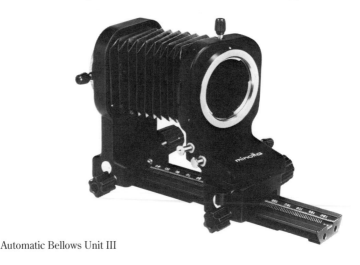

Automatic Bellows Unit III

simply take three of four shots and sort out the pictures afterwards. If the background was distant and blurred by shallow depth of field, nobody will even notice the slight deception. But motor drives and winders are not only useful for spectacular subjects like this. This type of photography makes it easier to take pictures of children playing, because you can concentrate fully on your subject if correct exposure and film transport are taken care of automatically.

Finally, motorized film transport systems have one last advantage. "Unmanned" photography would simply not be practicable without them. Imagine a camera installed at a nesting site. It is operated by remote control so that the birds are not disturbed, but it would be madness if you then had to run to the nest after every shot and advance the film. With a winder and motor, you can remain under cover and only come out after 36 shots in order to change the film.

Of course, the motorized film transports don't work without power. You need batteries which last a long time (approx. 50 films per set of batteries, if the batteries were fresh when you bought them). You should also buy an extra set of batteries and carry them in your camera bag. This precautionary measure is particularly to be recommended in winter because batteries don't particularly care for the cold.

Accessories - The Right Piece of Equipment for Every Purpose

I have referred to the remote control, which is part of the wide range of Minolta accessories, so while we're on the subject let's see what Minolta has to offer in this field.

Remote Control
The simplest means of triggering the camera without having your finger on the shutter release button is the self-timer. You switch it on and have ten seconds to get into the picture yourself. If you forget to push the AE lock/self-timer switch back to its initial position, nothing will happen the next time you press the shutter release button except that the red LED on the front of the camera will begin to flash. If you decide you don't want a delayed shutter action for a shot, you can simply return the switch to its original position. The sequence is interrupted and you can operate the shutter immediately by pressing the shutter release button. Be careful with pictures taken with the self-timer. The exposure is metered at the moment you press the shutter release button. If you happen to be standing directly in front of the camera at the time, the exposure will in all probability turn out to be incorrect. So always press the shutter release button from the side.

If you have an X-700, you can get by without pressing the shutter release button if you use either of the Remote Cords. RC-1000L measures 5m and RC-1000S is 50cm. These cables are convenient enough if you only want to

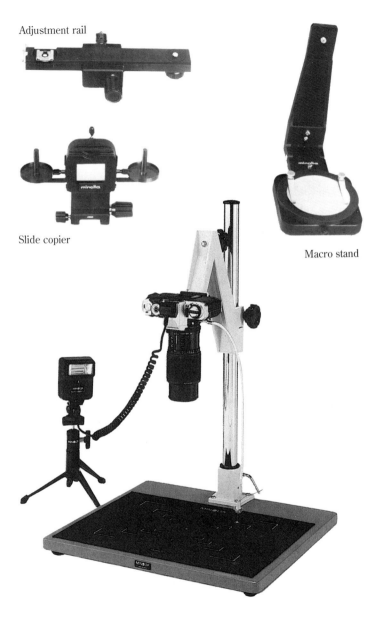

Adjustment rail

Slide copier

Macro stand

Copy stand II

put your X-700 on a long lead every once in a while. If, on the other hand, you intend releasing the shutter at long range very often, and you're sick to death of pulling on cables, you can turn to the Wireless Controller IR-1N Set, which consists of two parts. You hold the transmitter in your hand and the receiver is fitted into the accessory shoe on the camera. This unit, which has a range of over 60m, is only worthwhile if you also use a motor drive or winder; the use of the Power Grip 2 is to be recommended, particularly if you want to or need to work with flash. The Remote Cords and IR-1 Set cannot be used with the X-300s, since this model does not have a cable-release socket.

The Power Grip

The Power Grip 2, which has already been mentioned several times, is an outsize handgrip which is connected to the X-700 or X-300s by means of a bracket. The Power Grip 2 features a separate shutter release button and rotatable flashgun mount which also allows bounce flash shots using the Auto-Electroflash 280 PX. It is also the Power Grip 2 which supplies the 360 PX with the power it requires in order to flash three and a half times per second in synchronization with the automatic motorized film transport.

The Leader in the Close-up System

The bellows unit has been mentioned already in the section on macro lenses and lens heads.

The reproduction ratio is determined by two values; the focal length and the lens-to-film distance. A specific focal length and a specific lens-to-film distance result in an equally specific focusing distance and determine how large or how small the subject is reproduced on the film. As a greater lens-to-film distance results in a higher reproduction ratio if the focal length remains the same, the extension of the lens-to-film distance is the best approach to close-up photography.

Extension rings

In the case of the bellows unit, the lens-to-film distance is extended by moving the front standard, on which the lens is mounted in the usual way, away from the rear standard, which, in turn, is mounted on the camera like a lens. Both standards are connected by the concertina-like bellows, which is absolutely light-proof. Minolta offer three different bellows.

The most simple one is the Compact Bellows Unit. An expansion system permits the extension and shortening of the lens-to-film distance and at the same time guarantees the stability of the unit, which must, after all, be capable of carrying a lens. No commands are passed between lens and camera. Neither open-aperture metering nor the automatic aperture function operates. So after setting the focus, you stop down the lens to a medium setting in order to allow a sufficient depth of field, which makes the image in the viewfinder even darker than it is already as a result of the long lens-to-film distance. When the shutter is released the camera meters the light passing through the stopped-down aperture, evaluates it and selects an appropriate shutter speed.

Bellows Unit III is not much more convenient. However, the expansion system is replaced by a rail along which the standards are moved using a rack and pinion drive.

Finally, Bellows Unit IV is a so-called automatic bellows

143

unit, although this does not mean that the aperture is stopped down to the setting selected by the camera. Open-aperture metering and the automatic aperture function are, however, retained by means of a double cable release. When used with an X-700, this simultaneously closes the aperture and release the shutter. With an X-300s, only the aperture-control section of the cable is used and the camera is triggered using its own release button.

This is certainly an interesting aspect, but, in macro photography, many subjects are stationary. You have plenty of time to stop down the aperture before taking the picture and to open it again manually afterwards. So you should find Bellows Unit III adequate unless you need to use Bellows Unit IV's shift function for your pictures. As with the shift lens, undesired objects can be pushed out of the picture through the lateral displacement of the front standard. Vertical displacement is also indirectly possible,

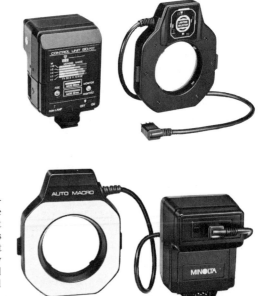

Minolta Auto-Electroflash 80 PX, the specialist amongst the PX flashguns has four flash tubes. It can be fitted quickly onto the attached lens and rotated about its axis.

as the bellows unit can be fitted to your camera sideways-on.

The front standard can be angled as well as moved laterally. This is the same movement as a swing front on a view or technical camera. It enables the photographer to increase the depth of field without having to stop down the aperture, and has nothing to do with the effect created by a shift lens. With a swing front, the angle of the plane of critical focus is adapted to the shape of the subject. When extending the depth of field in this way, it is necessary to adjust three planes. These are the cross-section plane through the lens, the film plane and the subject plane. The technique demands a lot of intuition, exact observation on the ground glass screen and plenty of practice. The shift function is no substitute for a large-format camera with a full range of movements.

Bellows Units III and IV can also be used to mount the lens in reverse position, whereby the rear element of a wide-angle lens is pointed at the subject. For this purpose, the front standard holding the lens is turned around, and the bellows unit is fitted to the filter thread on the front of the lens.

This rather complicated-sounding use of the lens can be simply explained. Normally, the lens has to focus on a subject which lies at some distance from the front of the lens, and project it, in sharp focus, onto the film, which is close to the rear of the lens. The arrangement is the same when a reversed lens is used with the bellows. The subject is close to the rear lens element, whereas the greater distance lies between the front lens element and the film - and so the optical performance of the lens is used most effectively.

There is one limitation on the use of reversed lenses. It only works well with very symmetrically constructed normal and wide-angle lenses, and is not worthwhile with long-focus lenses.

The very long lens-to-film distance which can be achieved with bellows units consumes a great deal of light. When

only a little light is able to reach the film, slow shutter speeds are necessary, and the small apertures required in order to produce at least some depth of field also play their part in making slow shutter speeds necessary. The use of fast or extremely fast films to counteract this is not to be recommended. The graininess associated with such films, which may still be acceptable in pictures within the range of normal reproduction ratios, has an undesirable effect here. There is only one solution; stabilizing the camera.

It is quite simple to screw a tripod under an X-700 or X-300s on which the bellows unit plus lens head has already been mounted, but it is by no means simple to achieve satisfactory results using this combination. Because if you're going to take macro shots, you will want to achieve a certain reproduction ratio. This, in turn, is achieved by setting the lens-to-film distance, and therefore the distance at which you want to take the picture. So you have no choice but to set up the tripod at the correct distance from the subject, which is easier said than done. Once you have got the distance more or less right, which might take a few minutes, you can carry out the fine adjustment. If you are not already working with maximum lens-to-film distance, you move the front standard slightly forwards or backwards and then move the rear standard, together with the camera, by the same amount, in the same direction, in order to maintain the same lens-to-film distance.

This is much simpler to do if you use an focusing rail onto which the entire macro outfit is placed and which, in turn, is mounted firmly on the tripod. After you have positioned the tripod at approximately the right distance from the subject, you only need to slide the whole combination of camera, bellows unit and lens forwards or backwards in order to set the focusing distance correctly.

The Copy Stand II combines a tripod and focusing rail in one. It consists of a baseboard, a column (60cm high) and a rail, which can be moved up and down the column and tightened in position.

This is not only used for copying pictures, graphics or

146

pages of books - it is also suitable for photographing small objects such as precious stones, leaves or transistors.

The problems described above occur not only when working with the bellows unit; similar difficulties are encountered when working with extension rings or tubes.

Extension tubes are available in sets, and a set consists of several rings of different lengths. By using individual extension tubes between camera and lens, or by combining several tubes, the lens-to-film distance - and thus the reproduction ratio - can be varied by specific degrees. Although the adjustable lens-to-film distance of the lens itself makes a variation of the lens-to-film distance possible, one cannot overlook the disadvantages in comparison with the continuously adjustable bellows unit.

You can find two sets of Minolta extension rings at your photographic supplier: the Automatic MC Extension Ring Set, which allows you to retain the fully-automatic aperture function, and the Extension Ring Set II, which denies you this convenience, therefore you have to close the aperture down manually before taking the picture and open it again afterwards.

Whereas a total extension of the lens-to-film distance by 63mm is possible with the automatic extension rings (the three rings are 14mm, 21mm and 28mm), the five manual extension rings provide you with a total extension of 56mm.

Lenses can also be fitted to the extension rings in reversed position. Whereas, in the case of the bellows units, the front standard holding the lens is simply turned around, the Reversal Ring II must be used with the extension rings in order to mount the lens firmly in place.

As with the bellows units, light is lost as a result of the greater lens-to-film distance achieved when working with extension rings, a disadvantage not shared by the achromatic close-up lenses. These are small optical systems rather than simple lenses. They are constructed of two lens elements which are cemented together, and are screwed into the filter thread of the lens. They act like

spectacles for a long-sighted person. The subject is so close to the lens that it can no longer be brought into sharp focus. However, the close-up lens reduces the focal length of the camera lens so that a subject at a distance of just over a metre can still be photographed with the 135mm lens. This example applies to close-up lens No.0. Two other close-up lenses from Minolta bear the designations No.1 and No.2. No.0, which has already been referred to, is designed for use with standard and long-focus lenses. No.1 is suitable for use with short telephoto lenses, standard and wide-angle lenses, whereas No.2 is reserved for standard and telephoto lenses.

Providing extra light at close range is a problem which has given some amateur photographers a few grey hairs. The short distance between the front of the lens and the subject means that it is by no means simple to concentrate light from lamps or flashguns on the subject.

For this reason, Minolta offer the Auto-Electroflash Macro 80 PX which, in contrast to the other flash units, is mounted on the lens rather than the camera. The ring-shaped reflector conceals four flash tubes which can be triggered individually or in different combinations. In order to illuminate the subject for easier focusing, focusing lamps are fitted at each corner of the unit.

Another item from Minolta's large accessories range proves its worth in the field of macro photography - when taking pictures near the ground or using the Copy Stand II - Anglefinder Vn, which is fitted onto the viewfinder eyepiece, makes it possible to see the viewfinder image from above, below or either side of the camera.

If you have difficulty focusing, this accessory also allows you to enlarge a section of the viewfinder image, of about 22mm in diameter, in order to be better able to tell the difference between sharp and unsharp. The Viewfinder Magnifier Vn enlarges the central portion of the screen image by 2.3-times, and can be folded out of the way when you want to see the whole screen.

Multi-Function Back

This is an additional accessory which is only usable with the Minolta X-700. It enables you to record the time or date on your film, to number each frame consecutively, or to print a fixed number. In addition, it has an intervalometer function, which enables the camera to be left unattended, and to take pictures at preset intervals. If a flash is being used the Multi-Function Back can turn it on and off as required, to avoid wasting battery power. The back can also be used for making very long exposures, outside the normal shutter speed range.

Why Use Filters?

In the macro range, you will hardly ever have so much light at your disposal that you will need to use neutral density filters to reduce it; on the other hand, this may well happen when taking pictures with fast film in daylight or when using the fixed-aperture mirror. So ND filters are not a superfluous investment, either for black-and-white or colour photography.

One other filter is essential for photographers who work with colour film, a polarizing filter. The effect of this type of filter is that they only admit rays of light whose waves vibrate in a particular direction. The fact that the other waves are blocked out means that colours become more saturated, and reflections on non-metallic surfaces (glass, water, car paintwork) can be controlled. The polarizer, as it is often called for short, achieves its greatest effect when the sun is at a sideways angle to the photographer; in order to get the optimum effect you have to adjust the filter by rotating it in its mount while observing the changing effect in the viewfinder.

Other filters which are frequently recommended are the UV filter and the skylight filter, the first of which is colourless, the second slightly pink. The UV filter should really be called a UV blocking filter, because it lets no ultraviolet rays through and thus stops the ultraviolet component of the light from turning pictures blue which

are taken at altitude or on the beach. The skylight filter has much the same effect, only to a greater degree.

The Minolta Portrayer Filters can also be classified under the category of filters. Type P makes the skin tones very soft, without affecting the other colours; Type S has a similar effect to a diffuser and is to be recommended for romantic portraits.

In addition to grey, polarizing, UV and skylight filters, Minolta also offer colour filters which have only a novelty value for colour photographers because they impose their colour on the entire picture. These filters are virtually indispensible for black-and-white photography, as they lighten parts of the subject corresponding to the colour of the filter. Yellow, orange and red filters bring out greater contrast in shots featuring blue sky and clouds - but whereas, with the yellow filter, the clouds simply stand out more clearly against the sky, which is grey in the picture, the red filter dramatises the same shot drastically, and the white clouds stand out in stark contrast to the almost black sky. The fourth colour in the group is green; filters of this colour are worth considering when taking landscape shots, to lighten the green of grass and trees.

Blue and amber filters, on the other hand, have a different task. As was briefly mentioned with reference to slide films, you can not only buy daylight films but also tungsten films which are suitable for use with photo-graphic lamps or room lighting. The blue and amber conversion filters are used in order to adapt one type of film to the other sort of light; the amber filter being used with tungsten film when this is being used in daylight. Without a filter, the pictures would have a pronounced blue cast. The blue filter comes in handy when a daylight film is used under artificial lighting conditions and you want to avoid the characteristic reddish-yellow colour cast. Whereas a blue cast tends to look unpleasant, there are many subjects which look quite good with a slightly reddish-yellow colour cast. Whenever you want to convey the evening atmosphere in a room or the warmth of

candlelight, it is a good idea not to use the blue filter.

And what about the filters which are regarded as creative filters? They produce starbursts or rainbows, colour part of the picture and leave the rest neutral, they multiply the subject and fill the picture with fog which was never there in reality. These filters, whether with screw-in fittings or as part of a filter system, certainly make it easy to achieve certain effects and are therefore to be recommended if you want unusual results. Whether they make better pictures or simply more eye-catching ones is a question which every photographer must answer according to his tastes. I tend to go along with the saying that, if in doubt, too little is better than too much.

How to Achieve the Technically Correct Picture

Once you have assembled your photographic outfit from the extensive Minolta range - according to your budget - nothing more stands between you and the hunt for your subjects. And when you consider that the X-700 and X-300s automatically do a lot of things correctly, that all the Minolta lenses are of excellent quality and that the flashguns guarantee correct exposure in the dark - well, it seems as though nothing much can go wrong.

It can, though! Earlier on, we already saw how you can handle situations where the exposure meter and automatic exposure system of the X-300s can lead you astray.

What other dangers lurk on the road to the technically perfect picture?

The greatest danger is that of camera shake. Although camera shake causes a loss of sharpness, it can also spoil pictures which could have been perfectly in focus. Camera shake means that the camera and lens is moved during the exposure, causing blurred outlines. The extent of this danger of camera shake depends on a number of circumstances.

Your physical condition, for instance. If you're a member of a rifle club, and are used to shooting one bull's-eye after another, you won't have any problem holding the camera steady. On the other hand, a sedentary office worker on a weekend hike in the mountains will be so exhausted after a few hours of uphill marching that his hands will shake slightly.

The risk of camera shake blur also depends on the focal length of the lens. The longer the focal length, the larger a subject is reproduced at a certain range, which means that the shake is also projected on a greater scale. If you stand next to a wall with a torch in your hand and move it upwards by a finger's breadth - the spot of light will hardly be moved from its initial position. Point the beam at the wall from a greater distance and again move the torch by a finger's width, and the movement of the spot of light will be easily defined. It's much the same when you hold a lens with a long focal length so you must bear in mind that the danger of camera shake increases with the focal length of the lens used.

The third important factor in assessing the risk of camera shake is the shutter speed. It is logical that any shaking is magnified in a thirtieth of a second rather than in a thousandth of a second!

To summarize these three points, you will achieve pictures which are free of camera shake if you bear in mind the following:

If you have the chance, support your camera on a park bench, a railing or against a lamp-post. Whenever possible, use a small tripod, such as the Minolta Mini-Tripod TR-1 or a Monopod, and use a sturdy tripod when working with long-focus lenses.

The basic rule. One divided by the focal length in mm gives you (approximately) the slowest shutter speed at which you can take steady hand-held shots. If in doubt, round off to the faster shutter speed.

A sharp and correctly exposed shot is in most cases merely a prerequisite for a good picture. If you are reproducing or taking pictures for purely documentary purposes, you can be satisfied with a technically perfect picture. But if you take photographs because you like beautiful pictures, you will have to try a little harder.

Whether or not you take this advice the important thing is that you have fun taking pictures and derive pleasure from your photographs. So hang on to the picture in which

your grandson smiles so wonderfully, and enjoy it - even if it is a bit shaky. Don't throw away the only picture which shows you on a camel - even if it is underexposed. After all, a photograph is a record of a moment in time which would otherwise be lost forever!

Minolta MD Lenses

Lens	Elements	Groups	Angle of view (diagonal)
Minolta MD-Fisheye 4/7,5 mm*	12	8	180°
Minolta MD-Fisheye 2,8/16 mm	10	7	180°
Minolta MD 4/17*	11	9	104°
Minolta MD 2,8/20 mm	10	9	94°
Minolta MD 2,8/24 mm	8	8	84°
Minolta MD 2/28 mm*	9	9	75°
Minolta MD 2,8/28 mm	7	7	75°
Minolta MD 3,5/28 mm*	5	5	75°
Minolta MD 1,8/35 mm*	8	6	63°
Minolta MD 2,8/35 mm*	5	5	63°
Minolta MD 1,2/50 mm*	7	6	47°
Minolta MD 1,4/50 mm*	7	6	47°
Minolta MD 1,7/50 mm	6	5	47°
Minolta MD 2/50 mm*	6	5	47°
Minolta MD 2/85 mm	6	5	29°
Minolta MD 2,5/100 mm	5	5	24°
Minolta MD 2/135 mm*	6	5	18°
Minolta MD 2,8/135 mm	5	5	18°
Minolta MD 3,5/135 mm*	5	5	18°
Minolta MD 2,8/200 mm	5	5	12°30′
Minolta MD 4/200 mm	5	5	12°30′
Minolta MD 4,5/300 mm	7	6	8°10′
Minolta MD 5,6/300 mm*	5	5	8°10′
Minolta MD-Apo 5,6/400 mm*	7	6	6°10′

Nearest focusing distance	Smallest aperture	Filter size Ø	Dimensions Ø x length	Weight
0,5 m	22	built-in	68 x 63 mm	355 g
0,25 m	22	built-in	64,5 x 43 mm	265 g
0,25 m	22	72 mm	75 x 53 mm	325 g
0,25 m	22	55 mm	64 x 43,5 mm	240 g
0,25 m	22	49 mm	64 x 39 mm	200 g
0,3 m	22	49 mm	64 x 50 mm	265 g
0,3 m	22	49 mm	64 x 43 mm	185 g
0,3 m	22	49 mm	64 x 40 mm	170 g
0,3 m	22	49 mm	64 x 48 mm	240 g
0,3 m	22	49 mm	64 x 38 mm	170 g
0,45 m	16	55 mm	65 x 46 mm	310 g
0,45 m	16	49 mm	64 x 40 mm	235 g
0,45 m	22	49 mm	64 x 36 mm	165 g
0,45 m	22	49 mm	64 x 36 mm	155 g
0,85 m	22	49 mm	64 x 53,5 mm	285 g
1 m	22	49 mm	64 x 65,5 mm	310 g
1,3 m	22	72 mm	79 x 96 mm	725 g
1,5 m	22	55 mm	64 x 81 mm	385 g
1,5 m	22	49 mm	64 x 72,5 mm	285 g
1,8 m	32	72 mm	78 x 133 mm	700 g
2,5 m	32	55 mm	64 x 116,5 mm	410 g
3 m	32	72 mm	77,5 x 177,5 mm	705 g
4,5 m	32	55 mm	65 x 186 mm	695 g
5 m	32	72 mm	83 x 256,5 mm	1440 g

Lens	Elements	Groups	Angle of view (diagonal)
Minolta MD-Apo 6,3/600 mm*	9	8	4°10′
Minolta RF 5,5/250 mm*	6 Element		10°
Minolta RF 8/500 mm*	6 Element		5°
Minolta RF 8/800 mm*	8 Element		3°10′
Minolta RF 11/1600 mm*	6 Element		1°30′
Minolta MD-Zoom 3,5/24–35 mm	10	10	84°–63°
Minolta MD-Zoom 4/24–50 mm	13	11	84°–47°
Minolta MD-Zoom 3,5–4,8/28–70 mm	8	8	76°–35°
Minolta MD-Zoom 3,5/35–70 mm*	8	7	63°–34°
Minolta MD-Zoom 3,5–4,5/35–105 mm	16	13	63°–23°
Minolta MD-Zoom 3,5/50–135 mm	12	10	47°–18°
Minolta MD 4/70–210 mm	12	9	34°–12°
Minolta MD-Zoom 4/75–150 mm	12	8	32°–16°30′
Minolta MD-Zoom 4,5/75–200 mm*	15	11	32°–12°30′
Minolta MD-Zoom 5,6/100–200 mm	8	5	24°–12°30′
Minolta MD 5,6/100–300 mm*	13	10	24°–8°10′
Minolta MD-Zoom 8/100–500 mm*	16	10	24°–5°
Minolta MD-Macro 3,5/50 mm	6	4	47°
Minolta MD-Macro 4/100 mm	5	4	24°
Minolta Auto-Bellows-Macro 3,5/50 mm*	6	4	–
Minolta Auto-Bellows-Macro 4/100 mm	5	4	–
Minolta Bellows-Micro 2/12,5 mm	4	4	–
Minolta Bellows-Micro 2,5/25 mm*	6	4	–
Minolta MD-VFC 2,8/24 mm	9	7	84°
Minolta Shift-CA 2,8/35 mm*	9	7	63°
Minolta Varisoft 2,8/85 mm*	6	5	29°

Nearest focusing distance	Smallest aperture	Filter size Ø	Dimensions Ø x length	Weight
5 m	32	built-in	108,5 x 373,5 mm	2400 g
2,5 m	16	built-in	66,5 x 58 mm	250 g
4 m	16	built-in	83 x 98,5 mm	600 g
8 m	16	built-in	127 x 178 mm	1960 g
20 m	22	built-in	179 x 325,5 mm	6290 g
0,3 m	22	55 mm	67 x 50 mm	285 g
0,7 m	22	72 mm	75 x 69,5 mm	390 g
0,8 m	22	55 mm	64 x 68,5 mm	375 g
1 m	22	55 mm	69 x 65,5 mm	355 g
1,6 m	22	55 mm	65 x 90,5 mm	480 g
1,5 m	32	55 mm	68,5 x 118 mm	480 g
1,1 m	32	55 mm	72 x 135 mm	635 g
1,2 m	32	49 mm	64 x 113,5 mm	445 g
1,2 m	22	55 mm	70 x 155 mm	640 g
2,5 m	22	55 mm	64 x 171,5 mm	595 g
1,5 m	32	55 mm	72 x 187 mm	700 g
2,5 m	32	72 mm	90,5 x 330 mm	2110 g
0,23 m	22	55 mm	64 x 55,5 mm	200 g
0,45 m	32	55 mm	66 x 88,5 mm	385 g
3,2:1	32	55 mm	57 x 24,5 mm	115 g
1,3:1	32	55 mm	57 x 28,5 mm	145 g
20,5:1	16	–	33 x 23,5 mm	40 g
9,3:1	16	–	33,5 x 17 mm	40 g
0,3 m	22	55 mm	64,5 x 50,5 mm	340 g
0,3 m	22	55 mm	83,5 x 71,5 mm	555 g
0,8 m	16	55 mm	70 x 80 mm	430 g